THE ART
OF THE
GRAPHIC
MEMOIR

Also by Tom Hart
Rosalie Lightning: A Graphic Memoir

THE ART
OF THE
GRAPHIC
MEMOIR

TELL YOUR STORY,
CHANGE YOUR LIFE

TOM HART

St. Martin's Griffin
New York

The Art of the Graphic Memoir. Copyright © 2018 by Tom Hart. All rights reserved.
Printed in China. For information, address St. Martin's Press, 175 Fifth Avenue, New
York, N.Y. 10010.

www.stmartins.com

The Library of Congress Cataloging-in-Publication Data Is Available Upon Request

ISBN 978-1-250-11334-4 (trade paperback)
ISBN 978-1-250-11335-1 (ebook)

Our books may be purchased in bulk for promotional, educational, or business
use. Please contact your local bookseller or the Macmillan Corporate and
Premium Sales Department at 1-800-221-7945, extension 5442, or by email at
MacmillanSpecialMarkets@macmillan.com.

First Edition: November 2018

10 9 8 7 6 5 4 3 2 1

For my friends and students in the SAW
Graphic Memoir class. Including Beth, Emma,
Madeline, Jesse, Xris, Elizabeth, Lynsey, Edie,
Erin, Elise, Jill, Darlene, and Mister Captain.

CONTENTS

PART I: GETTING STARTED

We will prime ourselves by looking at how comics work differently from other media.

We'll look at finding more material than we think we may already have, so we have lots to choose from.

We'll look at ways of structuring our story into an outline.

We'll look at how visual style impacts the telling of the story, and how to move forward with our own style.

I will provide some advice and reflection on just getting started.

PART II: GOING DEEPER

Here we'll look more closely at structure and go beyond the outline into how best to tell the story.

We'll delve into how to use metaphor, analogy, visual motif, and design to express our story.

How the process of working on the book can change you, and how the experience retold can lead to a new, fuller experience.

We will look at how to work through the sometimes long process of drawing your stories into comics.

INTRODUCTION

In 2010, I was an award-nominated, acclaimed cartoonist and teacher with no interest in creating autobiography. My work and life led me to find creative fufillment in fiction—usually blends of serious and silly fables.

That is, until 2011, when my daughter died suddenly just shy of her second birthday.

The shock of this caused me to bury myself in the actions I knew best: writing and drawing. I wrote about what I was going through, and soon realized I needed to wrestle with it in drawing, too.

Thus, I began my first autobiographical comic, a graphic memoir, *Rosalie Lightning* (2016, St. Martin's Press).

I've always been an artist to look to the great work before me for inspiration and guidance. And so in creating my story, I turned to lots of master examples of the genre.

In this book I want to share with you everything that I learned in looking at these master examples, as well as how I tried to transmute their wisdom as I worked on *Rosalie Lightning*. In the "My Story" sections, I'll show detailed notes, sketches, and drafts that relate to the topics I've brought up.

This book is designed to get you, too, from initial thoughts, ideas, and memories to a finished graphic memoir, so in addition to my own notes and experiences, I'll also review those master examples and complete exercises to get you better and deeper into your own story. We'll go step by step from idea to completion and you will gather lots of tools and inspirations on the way.

Our path is divided into nine sections, and in each section and step we'll take a quick look at a few great graphic memoirs and then we'll complete one exercise and look to at least three optional exercises to get us further along.

I run a comics school in Gainesville, Florida—The Sequential Artists Workshop (SAW). I've had the privilege of guiding many students through the telling of their own stories. This book is a product of their energy and strength as much as mine.

Whether you're eager to share stories you've had inside you for a long time, or want to draw stories that you've previously told some other way, this book is designed to inspire and get you there.

Ultimately, telling our stories strengthens us, deepens us, and makes us more alive, compassionate, and empathetic, as it connects our lives to history and to the world around us. It helps us connect broadly across time and across peoples.

It changes us; it changes the world.

If [these thoughts] are not the riddle and the untying of the riddle they are nothing . . .

—Walt Whitman; *Song of Myself*

PART I

GETTING STARTED

Everyone has a story to tell. Over the course of a life, we tell so many stories, and hear so many stories over meals, during free time, during work, play, in public space or in private.

We are so used to it that we don't even think about structuring our stories, or editing parts in or out, or the tone of our voice or anything, we just tell our stories.

But when we choose to move from the merely social world to telling our stories in a more complicated medium like, say, a graphic memoir, then suddenly we realize there is a lot to think about!

Style, rhythm, panel arrangement, visualization, structure, and even just how do I go through with this anyway?

This book aims to help you internalize the tools you will need to tell your graphic memoir. When you learn all the elements above, you are on the road to literacy in this unique medium.

So first, let's get started, and look at the basics.

CHAPTER 1

WHY COMICS?

To begin, why do we want to tell our story in comics? We don't really need an answer to this, but asking it might help us make better visual and sequential choices once we get going.

Comics are inherently visual, like cinema or animation, but they're also intimate, making a one-to-one connection with the reader as do novels or poetry.

Comics have in their history early glyphs and alphabets that communicate through pictures. Comics may be closer to runes than to movies. Some historians believe that even some cave paintings were meant to be read in sequence.

Or maybe comics are more like puppets—in both, we look at fake versions of people, whether made up of foam and cloth or made up of drawings. They don't move like real people; in comics they don't move at all.

Or maybe comics are like theater, the boxes and panels reflecting the proscenium and the stage.

Or maybe comics are a lot like music, the rhythm of the panels and pages reflecting the beats and measures in a song, and the directness of the drawings hitting our emotions like melody.

Or ultimately comics are most like *comics*, and every artist will bring his or her talents, drives, and eccentricities to it. Which is why we study them: to see what others have done, and to mimic and learn as we develop our own voice to tell our own story.

Since most comics are drawn (though they are occasionally painted, collaged, or even photographed), let's begin by looking at three artists who love to draw and whose narrative voices are inherently connected to their love of and facility with drawing.

SMILE
by Raina Telgemeier

Raina Telgemeier clearly loves drawing. You can tell from her clean, exaggerated style. You can see the joy she experiences in stretching these faces and bodies to their limits.

CONSISTENT DRAWINGS

Telgemeier's characters are consistent, expertly drawn, and very funny. Her readers are young adults and this is how they want to read her story. They want clean, easy-to-read cartoons that are elastic and occasionally grotesque. This distortion of the characters' faces and bodies reflect how childen and adolescents feel about their own bodies and appearances and owes a lot to the exaggeration in classic comics and cartoons.

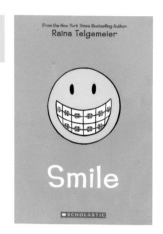

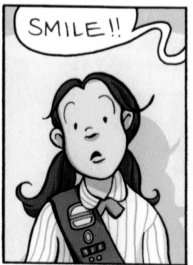

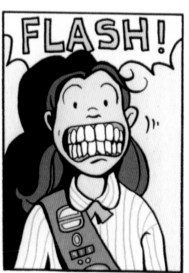

HOW SHAPES FIT TOGETHER

Raina by Raina

Telgemeier talks a lot about drawing on her blog.

She talks about drawing as a child. "My earliest drawings are just scribbles and shapes, but they're all sort of rounded, featuring a lot of bubble-headed figures."

And then she talks about being inspired as a child by TV characters like the Muppets, Smurfs, Care Bears, and Mickey Mouse and about copying "how other artists fit shapes together."

Slowly she began to draw everything around her like cartoon characters: "I also drew myself, my friends, my teachers, my family… anybody I came in contact with was likely a subject of my comics!"

In college, "I really enjoyed my classes … especially figure drawing classes, learning about human anatomy and trying to capture difficult poses … but, my faces were always cartoony."

And she talks finally about how in a cartooning style "your hand memorizes certain lines and shapes, and starts to simplify them."

Telgemeier has loved drawing since she was a child and clearly continues to love it years into being one of America's best-selling cartoonists. This delight in lines, shapes, faces, bodies, characters, and stories keeps her work warm, joyous, and infectious.

Telgemeier loves faces and shapes.

BAREFOOT JUSTINE

by Justine Mara Andersen

My SAW (Sequential Artists Workshop) colleague Justine Mara Andersen is an artist like few others. She is a master of traditional light and shadow, anatomy and old-school comic book lines and shading. She draws the beautiful and the ugly with the same precision.

BEAUTY AND HORROR

In her memoir-in-progress, *Barefoot Justine*, which is about her life transition from one gender to another, she uses all of her skill and visual imagination to make the story alive, visible, and symbolic.

Idealized imagery pervades the book, for instance in the lush, decorative images on the left and right. But then when the need arises, Andersen uses different tools and renders in a more grotesque and humorous style, such as the image below of her asking her friend for some of his mother's painkillers. This image was inked with a toothpick as she renders herself lumpy and dissolving, a hopeless marshmallow.

Justine by Justine

> No one was around; perfect. So I asked him to look at my work...

She uses this idealized version of herself to imagine herself into existence. I'm moved by this panel where she, in the present, is holding tiny little past *him* up, meeting an artistic mentor for the first time.

In another panel, she draws her idealized self with such grace and beauty, and the internal demons and voices with such grotesque ferocity that you realize that the person telling the story has seen both sides of the imagination: the exalted, and the abased.

In her memoir, she tells about spending ten years drawing a comic about a girl in an adventureland full of space weapons, threats, and captivity. She says that she later realized she didn't merely love this character that she created, she subconsciously was trying to become her. And her memoir tells that story.

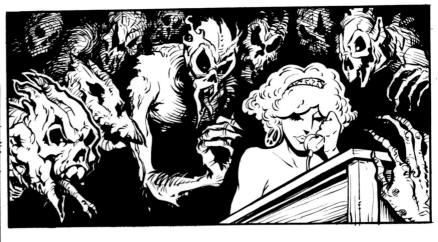

Andersen is an example of a person who, having studied hard to perfect her craft, now has the tools to make her dreams—and her own self—manifest.

THETH
by Josh Bayer

Josh Bayer's *Rom* and *Theth* are memoirs that sometimes masquerade as revisions of other comics.

LOOSE, VARIED DRAWINGS

Bayer has a loose, inconsistent drawing style but his readers connect with its feral qualities. Bayer, too, loves to draw and it shows in him explosively trying new things on every page to get his story out. Characters brood, argue, fight, and strive for better situations while moving through this rich variety of coarse lines and radical marks.

Josh Bayer's lines do a lot of the talking for his characters. Theth doesn't speak much, but the lines he's drawn with are full of tension and intercoiled rage and resentment and fear.

Theth by Josh

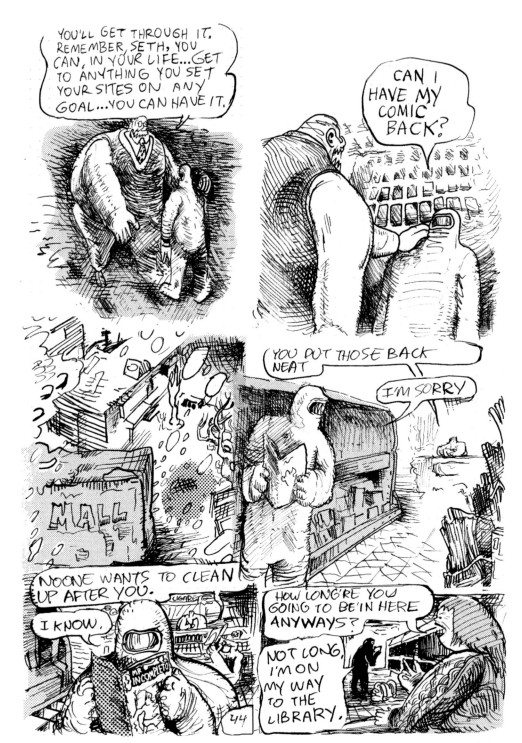

Josh Bayer's main character wears a helmet and sort of radiation suit, casting him into the world of '70s and '80s super-hero comics that he is so excited by.

A PHYSICAL ACT

In most cases, the creator of the memoir loves the art of drawing. That act of drawing is a way to relive the story, to put yourself as a creator back in time with new eyes and new tools.

Along this line, Alison Bechdel (*Fun Home*, 2007, Mariner Books) shoots reference photos of herself in virtually every scene in her stories. Having done the same thing myself at times, I can only imagine that Bechdel experiences the story even more deeply in a physical way because of this restaging, allowing her to inhabit the story in order to make fuller sense of it in context. Body, emotions, and intellect all work together in Bechdel's powerful work, which we'll see more of in future chapters.

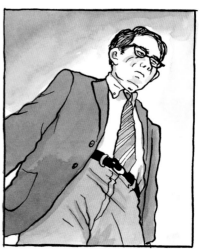

Bechdel in a staged reference shot for a drawing of her own father.

WHY COMICS?

So if the question is "Why comics?" I hope I've given you some ways to think about answering it by connecting it to drawing.

The process of drawing is a fabulous one, markedly different from traditional writing, talking, or thinking. Drawing is more animal, maybe more childish. It's challenging, but it's mesmerizing, surprising, and rewarding when it goes well.

But know, too, that it's okay to not know the answer to Why Comics? If the impulse is strong enough, follow it and it will reveal the answers later.

MY STORY

1991

1992

1992

1992

1993

1994

1995

1996

1997

1998

1999

2000

2001

2003

2004

2005

2006

2007

2008

2009

2010

2011

DRAWING THROUGH EMOTION

In my own case I have always used comics to explore my emotional landscape.

The montage of drawings to the left shows the manner in which I've drawn myself or variations of myself for twenty years.

The style, even when crude and inexperienced, is always emotive. The characters wildly express themselves with their faces and their gestures, expressing, I suppose, my sort of high-strung nature.

It was with drawing and writing that I dealt with and maneuvered within the emotional world for most of life.

So then when tragedy hit me, I had nothing to turn to except that same writing and drawing.

Though I've always loved drawing, the act of creating my book reminded me that in my case, the writing comes first.

I did tons and tons of preparatory writing. And then I drew through those written notes, the process of which became a way to revisit the experience while applying my more reflective and alert brain to it.

A PHYSICAL ACT

One of the ways of drawing that I turned to was the use of shading film—little mechanical dots on transparent sheets of sticky film. I turned to this partially because it was how I first learned and longed for the familiarity of it, but also because it caused me to draw with a knife. The tragedy of losing my daughter left me so raw and enraged that carving into film and into the paper was cathartic. Drawing for me needed to be a more solid, three-dimensional process.

EXAMINING THE CRAFT

I too have a profound love of drawing, but in fact it's often quite difficult for me. Drawing things "right" is usually a battle (though one that I enjoy engaging in, like a sport). Even while drawing silly cartoons, which is most of what I did for twenty years before my memoir, I had to fight to get body language, anatomy, and expressions right.

But in the case of Rosalie's book, I had a much more difficult series of challenges. I had to tell the story, engage with the material, and express something dark and sometimes scary. Not the usual thing I drew.

Early on in the book, I came upon this image by Jack Davis from an old 1950s EC *The Vault of Horror* comic (right). I was never a fan of genre comics, but this picture captivated me. I could identify with this horrific imagery for the first time in my life.

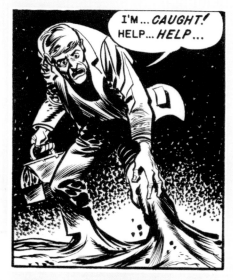

But I realized that I also liked looking at the craft of it.

So to draw the difficult parts of this book, I started there, with these horror comics. I examined the brushy way Johnny Craig built up the layers of ink to create this muddy pit (right), and carved away at it to create rain, and also the way Davis used ink to create the sticky, murky goo above.

I used these techniques as guides toward the type of representation I was aiming for.

FAMILY AS CHARACTERS

Tom by Tom

Leela by Tom

One thing I especially needed to do in order to understand and relate to this ordeal was turn my wife and myself into cartoon characters.

Because I have drawn so many cartoon characters for so long, it seemed I had to develop versions of my family in this same language.

At this cartooned distance, I was able to see us as travelers in a journey. And there was something moving to me about rendering my wife and myself in cartoon form. I especially felt that this panel below both felt like us and felt like genuine characters in a cartoon book. The melding of the two was something I was shooting for.

Rosalie by Tom

I IMAGINE A CARTOON CHARACTER, SOBBING AND HEADLESS, WANDERING THIS SNOWSCAPE, LOOKING FOR...

MORE OPEN HOUSES.

THE STRUGGLE TO DRAW

Some of the drawings that I wrestled with and that worked.

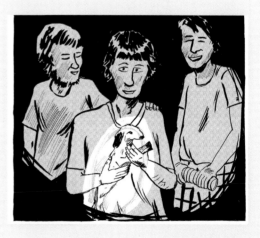

And some that I wrestled with that never wound up working for me.

DO THIS

GET INSPIRED!

For this first section, just get inspired. Read some comics! Lots of them.

Read any of the twenty-seven memoirs listed in this book. Those books, along with other great examples, are organized here loosely by subject matter. Start by reading some of them, firing your synapses, and getting primed to tell your own story.

This list below is highly subjective, accidental in many ways, and sadly incomplete. I hope you'll use it merely as a starting point.

SOME RECOMMENDED GRAPHIC MEMOIRS

CHILDHOOD STORIES

Smile by Raina Telgemeier
Theth by Josh Bayer
Kampung Boy by Lat
NonNonBa by Shigeru Mizuki

See also:
Total Trash by Jen Sandwich

COMING-OF-AGE STORIES

Perfect Example, by John Porcellino
We Can Fix It! by Jess Fink
100 Demons by Lynda Barry
Why I Killed Peter by Alfred and Olivier Ka

See also:
Binky Brown Meets the Holy Virgin Mary by Justin Green
Persepolis by Marjane Satrapi
The Playboy by Chester Brown
I Never Liked You by Chester Brown
Today Is the Last Day of the Rest of Your Life by Ulli Lust
Over Easy by Mimi Pond
Couch Tag by Jesse Reklaw
The Arab of the Future by Riad Sattouf
Alec: The King Canute Crowd by Eddie Campbell
Freddie & Me by Mike Dawson

Chicago by Glenn Head
Blankets by Craig Thompson
My Friend Dahmer by Derf Backderf
Escape from "Special" by Miss Lasko-Gross
Drinking at the Movies by Julia Wertz
The Quitter by Harvey Pekar and Dean Haspiel
The Diary of a Teenage Girl by Phoebe Gloeckner

STORIES ABOUT PARENTS

To the Heart of the Storm by Will Eisner
Fun Home by Alison Bechdel
Can't We Talk About Something More Pleasant? by Roz Chast
Calling Dr. Laura by Nicole J. Georges
Soldier's Heart by Carol Tyler
Are You My Mother? by Alison Bechdel

See also:
Fatherland by Nina Bunjevac
Displacement by Lucy Knisley
Special Exits by Joyce Farmer
All the Answers by Michael Kupperman

LOVE AFFAIRS

Grafitti Kitchen by Eddie Campbell

David Chelsea in Love by David Chelsea
Dance by the Light of the Moon by Judith Vanistendael
Silly Daddy by Joe Chiappetta

See also:
My New York Diary by Julie Doucet
Clumsy and *Unlikely* by Jeffrey Brown
Invisible Ink by Bill Griffith

ILLNESSES AND GRIEF

Monsters and *Sick* by Ken Dahl (Gabby Shulz)
Epileptic by David B.

See also:
Marbles by Ellen Forney
Our Cancer Year by Harvey Pekar, Joyce Brabner, and Frank
 Stack
Billy, Me & You by Nicola Streeten
The Story of My Tits by Jennifer Hayden
Cancer Vixen by Marisa Acocella Marchetto
Stitches by David Small
Tangles: A Story About Alzheimer's, My Mother, and Me
 by Sarah Leavitt
*Things to Do in a Retirement Home Trailer Park . . . When You're
 29 and Unemployed* by Aneurin Wright

TRAVELOGUES

How to Understand Israel in 60 Days or Less by Sarah Glidden

See also:
Pyongyang by Guy Delisle
Follow Your Art by Roberta Gregory
Red Eye, Black Eye by K. Thor Jensen
But I Like It by Joe Sacco

STORIES ABOUT NOW

Make Me a Woman by Vanessa Davis
July Diary and *The Voyeurs* by Gabrielle Bell

See also:
American Elf by James Kochalka
American Splendor by Harvey Pekar
Whatever by Karl Stevens
Miseryland by Keiler Roberts

REFLECTIONS

The Fate of the Artist by Eddie Campbell
Need More Love by Aline Kominsky-Crumb
Stop Forgetting to Remember by Peter Kuper

STORIES ABOUT WAR AND HISTORY

Maus and *MetaMaus* by Art Spiegelman
The Photographer by Emmanuel Guibert, Didier Lefèvre, and
 Frédéric Lemercier

See also:
We Are on Our Own by Miriam Katin
A Sailor's Story by Sam Glanzman
Darkroom by Lila Quintero Weaver
Full Body Scan by Miki Golod
March by John Lewis, Andrew Aydin, and Nate Powell
A Game for Swallows by Zeina Abirached
Barefoot Gen by Keiji Nakazawa
Onward Towards Our Noble Deaths by Shigeru Mizuki
Escape from Syria by Samya Kullab, Jackie Roche, and Mike
 Freiheit
Vietnamerica by GB Tran
American Widow by Alissa Torres and Sungyoon Choi
The Best We Could Do by Thi Bui

STORIES ABOUT JOBS AND OTHER EXPERIENCES

Turning Japanese by MariNaomi
Doing Time by Kazuichi Hanawa

. . . and many more!

FOR FURTHER READING

Some great drawing books to get you started:

The Joy of Drawing by Gerhard Gollwitzer
The Zen of Seeing by Frederick Franck
Drawing on the Right Side of the Brain by Betty
 Edwards
How Pictures Work by Molly Bang

Exercises

CHAPTER 2
GATHERING MATERIAL

Maybe you want to tell the story about your childhood, and it's got lots of great stories and anecdotes but you haven't begun to structure it. Or maybe you want to tell about a particular ordeal, in which case you know the path of events and you need to elaborate it, or even edit it down to what is essential.

Assuming you know some of the story but not all of it, or that you know all of it but want to make sure you're prepared to start, let's look at the process of gathering material.

Let's review three memoirs that started as series of explorations and were later brought together into a whole unified package.

PERFECT EXAMPLE
by John Porcellino

John Porcellino's *King-Cat* is an autobiographical series of stories that has been coming out since the early '90s. Many of the early stories are ones about young adulthood or adolescence—stories about jobs, love, art, friends. Porcellino's stories are simple and often short but honestly observed and detailed. His books have been collected in many large collections. At least two of his larger series of stories have been collected under unified covers: *Mosquito Abatement Man*, about his time killing mosquitoes for a living, and *Perfect Example*, about his summer between high school and college.

Perfect
Example

John Porcellino

LARGE STORY FROM SMALL STORIES

King-Cat is the epitome of the cartoonist "sandbox" format, a periodical of small stories, often with repeated themes. Much like a musician releasing albums of songs year after year, Porcellino has released *King-Cat*.

Porcellino drew *King-Cat* for years before the high school and *Mosquito* stories emerged. By 1998, when the *Perfect Example* stories emerged, Porcellino had been making his comics monthly for four years.

Perfect Example features a multitude of chapters, arranged by the author in a way ultimately unrelated to the order he created it in. The book begins with a small piece from 1996, then a story from 1994, then the bulk of the book is a longer story told in 1996-1998. Finally it ends with a coda from 1996.

John by John

In *Perfect Example*, these stories emerged around other stories, and he picked them out later and brought them together into a unified whole.

Porcellino used a similar structure for *The Hospital Suite* (Drawn & Quarterly, 2013), a memoir comprised of several related long stories.

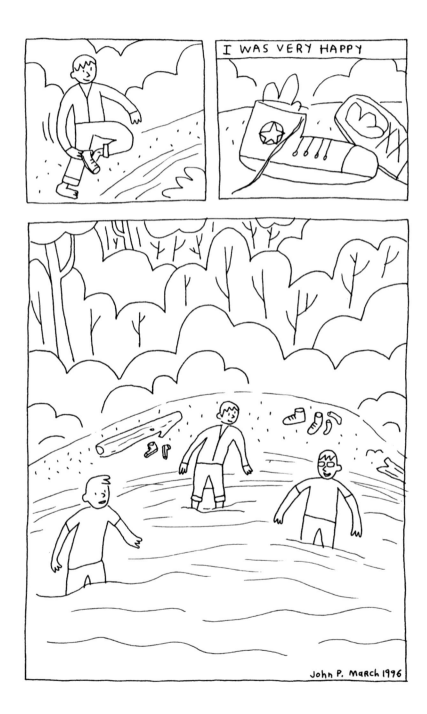

SILLY DADDY
by Joe Chiappetta

Joe Chiappetta was a young man with a new baby and a failing marriage when he began his *Silly Daddy* comics.

ANECDOTES AND REFLECTIONS

These comics are all anecdotes about his life with his new daughter, anecdotes of a "silly daddy." He was fast and focused in his comics. He wrote anecdotes about everyday things like biking, jobs, and art shows, but also more serious subjects like his divorce and about the single time he struck his daughter.

Later, his explorations led him to imagine stories of the family far into the future.

His time doing *Silly Daddy* was a fast and raw processing of life's events inside an artistic forum.

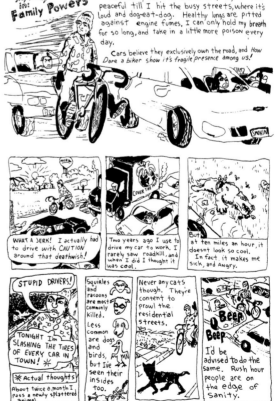

Joe's vivid imagination and fearless inventiveness remain inspirations to autobiographical cartoonists everywhere.

When it came time to publish his major *Silly Daddy* collection, it was comprised of issues 1-3, 5, 7, 9-12, and only parts of 4 and 8 and 14 and some others. Many of these chapters had some small alterations, and in some cases new pieces were inserted in between the older chapters. In some places, small strips created years later were inserted to enhance the flow and the tone.

Joe by Joe

In both the case of Porcellino and Chiappetta, they created without overthinking the final structure, and applied structure and refinement later.

Joe has this great inspirational quote: "This isn't the bomb squad, so take unnecessary chances."

Being free and fearless in his art gave him the material to collect and shape later.

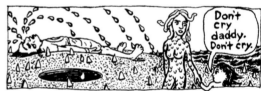

100 DEMONS
by Lynda Barry

Lynda Barry's *100 Demons* is unified by theme only. Each roughly nine-page comic comes from a list of personal "demons"—bad experiences, negative influences, or distressing stories in her life. The list includes: for instance, "Head Lice," "Hate," "Girlness," her "First Job," etc.

From this list, a sort of memoir of reflection and loss is constructed. It's a beautiful organic book.

STORIES FROM A THEME

One of Barry's intuitive methods of gathering material is detailed in her *What It Is* (2008, Drawn & Quarterly). She starts with an object, place, or theme, and makes a list of memories that occur to her, in whatever order they arrive in her brain.

From there, she takes one or two that seem to want to be written, and calmly writes them out, in longhand, focusing on the images and sounds and senses in her memory as they unfold in time.

Lynda by Lynda

Barry's belief is that our minds and memories are full of powerful, forgotten images and stories, and her methods are designed to help us reveal and express them.

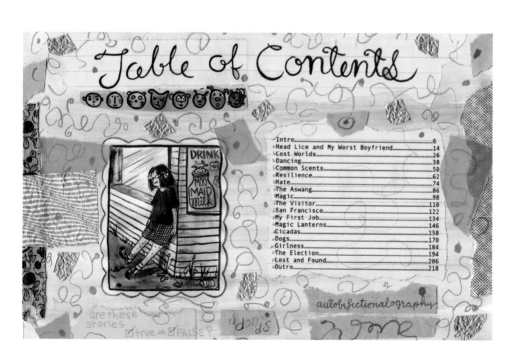

MY STORY

LISTS AND WRITING AS BEGINNING MATERIAL

I gathered material by writing, writing, writing. Early on I began constructing possible visual sequences, even thumbnailing, but mostly I just wrote until I didn't have anything to say anymore.

Inspired by Lynda Barry (I had taken a workshop with her ten years prior), I made lists, too, of important events and dialogues, etc. A lot of these didn't make it in but were important to investigate early on.

The two-inch binder above and these excerpts became the raw material for a 272-page book. Much of this writing was never used and this was a lesson for me: *Gather more raw material than you think you need so you're never desperate for something to say on the page.*

EXAMPLES

Here are a couple of examples of writings and the comic sequences they became.

In New Mexico, we pulled into a motor lodge during a terrible snowstorm. Above right is some of the writing I did about that.

Taos NM, 12 5 2011, last nigh w as utter hell designed for us i'm sure w e pu
the drive to taos is upphill and little spooky, a little lovely, but spooky, and asw e're driving through the main part of tow n, looking ofr our hotel w e find it slow ly slow ly because now its icy out and the w ind is startingto pick up, w e inch in. the ice is blow ing fast now , w e park about 60 feet from the entrance. sit in the car, look at the ice blow ing over the w indsheild and w indow s . ok craplet's drive over, It you out to deal w ith the the check in and I'll get the bags in

i let leela out and this next minute is the w orst minute of my life since that day. i am in a sw eater , shivering , dragging luggage out a mere 15 feet to the entrance. three bags, 2 trips, i amshivering dow n to the core of my skeleton, my emotional core, w hatever it is made of, is broken, i am about to malfunction, probably die.

I've alw ays had this reactionto cold plus heartbreak. w hen i broke up w ith my firstgirlfriendat 22, i shiveredfor w eeks, i thought i w ould die, alli could do w as layer and be around people w ho i w ould then run from. I shivered, broken sure i w as dying, listening to music.

This w as that shivering: heatbroken, desolate, my emotions completely upended. This storm designed by specifically to abrate my raw heart.

cut to- you got us a room? she draw s a map- drive around this corner, past thepool, you can parkhere or here. it's room 201.

i have to go back out. w ind.

just shove it all in the back seat. hurry hurry

i cant see it w e drive for around 5 minutes- is that it? 401. w e circle the hotel. crap. around the entrance again and the past the pool. w e squint- thats 201. w here can w e park. you can parkthere? that's 30 feet aw ay. is that a space? its covered in snow , i drive over it, ok let's just do it.

INSIDE its cold w e're shivering rubbing our arms get shoes off i run to the heater w hich is of course on cool, i crank it. w e do w e can I make a rare effort to send a tw eetto the w orld. ice storm in taos, its ahellhole. How often does Taos get called a hellhole? I'll

The comic page was rougher, more immediate, I omitted a lot of the text, even resorting to a list of nouns: Sweater. Hat. Scarf. Big Coat, etc.

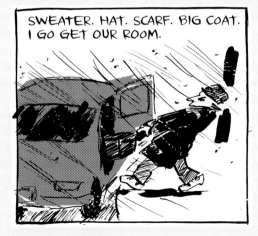

Later in New Mexico, I wrote down a dream (below). Months or years later I drew it, and it became four panels, much quicker. For the sake of quick immediate imagery, a lot got stripped away.

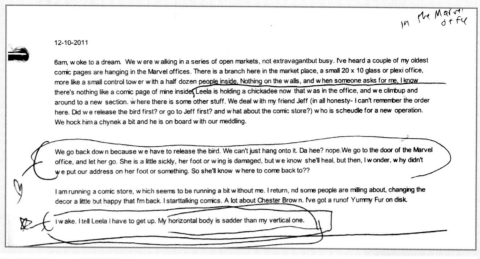

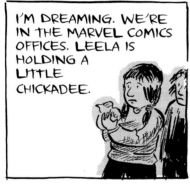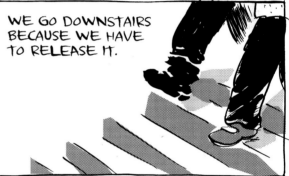

Below is another list of thoughts and impressions that occurred to me during the intense five weeks depicted in this book. Almost none of this was used; I believe only the underlined and crossed-out notes were used at all.

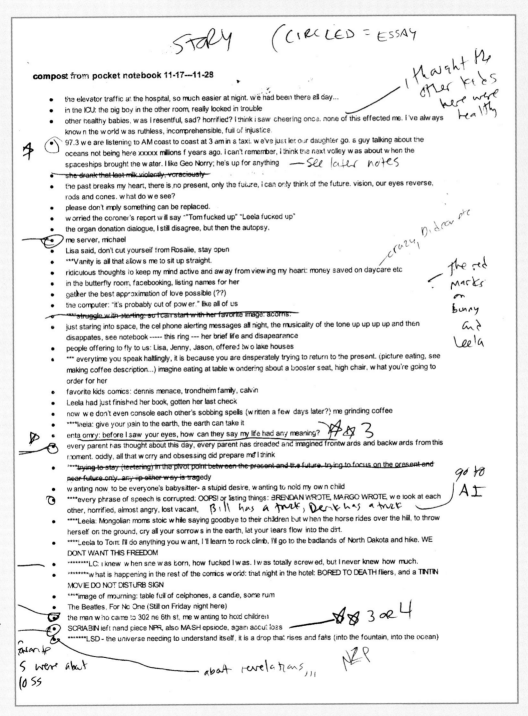

STORY (CIRCLED = ESSAY

compost from pocket notebook 11-17—11-28

I thought the other kids here were healthy

- the elevator traffic at the hospital, so much easier at night. we had been there all day...
- in the ICU: the big boy in the other room, really looked in trouble
- other healthy babies, was I resentful, sad? horrified? I think I saw cheering once. none of this effected me. I've always known the world was ruthless, incomprehensible, full of injustice.
- 97.3 we are listening to AM coast to coast at 3 am in a taxi. we've just let our daughter go. a guy talking about the oceans not being here xxxxx millions f years ago. i can't remember, i think the next volley was about when the spaceships brought the water. I like Geo Norry; he's up for anything — See later notes
- ~~she drank that last milk violently, voraciously~~
- the past breaks my heart, there is no present, only the future. i can only think of the future. vision, our eyes reverse, rods and cones. what do we see?
- please don't imply something can be replaced.
- worried the coroner's report will say -"Tom fucked up" "Leela fucked up"
- the organ donation dialogue, I still disagree, but then the autopsy.
- me server, michael

crazy, Did draw etc

- Lisa said, don't cut yourself from Rosalie, stay open
- ***Vanity is all that allows me to sit up straight.

The red marks on Bunny and Leela

- ridiculous thoughts to keep my mind active and away from viewing my heart: money saved on daycare etc
- in the butterfly room, facebooking, listing names for her
- gather the best approximation of love possible (??)
- the computer: "it's probably out of power." like all of us
- ~~***struggle with starting, so I can start with her favorite image: acorns.~~
- just staring into space, the cel phone alerting messages all night, the musicality of the tone up up up up and then disappates, see notebook ----- this ring --- her brief life and disapearance
- people offering to fly to us: Lisa, Jenny, Jason, offered two lake houses
- *** everytime you speak haltlingly, it is because you are desperately trying to return to the present. (picture eating, see making coffee description...) imagine eating at table wondering about a booster seat, high chair, what you're going to order for her
- favorite kids comics: dennis menace, trondheim family, calvin
- Leela had just finished her book, gotten her last check
- now we don't even console each other's sobbing spells (written a few days later?) me grinding coffee
- ****leela: give your pain to the earth, the earth can take it
- enta omry: before I saw your eyes, how can they say my life had any meaning? ~~1 2~~ 3
- every parent has thought about this day, every parent has dreaded and imagined frontwards and backwards from this moment. oddly, all that worry and obsessing did prepare me? I think
- ~~****trying to stay (teetering) in the pivot point between the present and the future. trying to focus on the present and near future only. any ip either way is tragedy~~

go to AI

- wanting now to be everyone's babysitter- a stupid desire, wanting to hold my own child
- ****every phrase of speech is corrupted. OOPS! or listing things: BRENDAN WROTE, MARGO WROTE, we look at each other, horrified, almost angry, lost vacant, Bill has a truck, Denk has a truck
- ****Leela: Mongolian moms stoic while saying goodbye to their children but when the horse rides over the hill, to throw herself on the ground, cry all your sorrows in the earth, let your tears flow into the dirt.
- ****Leela to Tom: I'll do anything you want, I'll learn to rock climb, I'll go to the badlands of North Dakota and hike. WE DONT WANT THIS FREEDOM
- ********LC: I knew when she was born, how fucked I was. I was totally screwed, but I never knew how much.
- ********what is happening in the rest of the comics world: that night in the hotel: BORED TO DEATH fliers, and a TINTIN MOVIE DO NOT DISTURB SIGN
- ****image of mourning: table full of celphones, a candle, some rum
- The Beatles, For No One (Still on Friday night here)
- the man who came to 302 ne 6th st, me wanting to hold children — ~~1 2~~ 3 or 4
- SCRIABIN left hand piece NPR, also MASH epsiode, again about loss
- ********LSD - the universe needing to understand itself. it is a drop that rises and falls (into the fountain, into the ocean)

S were about loss about revelations,,, NPR

EVEN MORE LISTS

This list at right of "Portents that aren't portents" remained in list form on the final page.

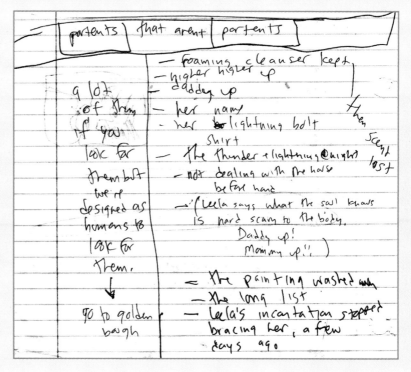

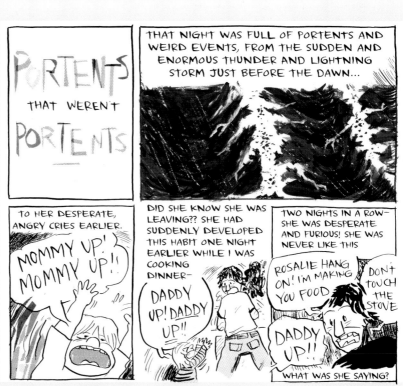

LOOKING FOR THEMATIC LINKS

In the image below, I was writing about horses that we saw along the road, and was trying to tie it into a powerful drawn image I'd seen of several horse hooves kicking up dirt and dust and wildly coming toward the reader. On the lined paper is my sketch of it. It's a vivid, haunting panel from a Marvel comic I had archived (*John Carter, Warlord of Mars* by Gil Kane, I think) but I couldn't find a way to link it to everything else. It didn't make it into the final book.

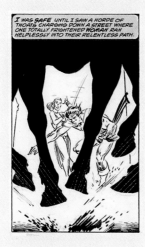

This image from an old Marvel comic inspired me but nothing directly came of it.

DO THIS

Let's choose one organizing category and make a list from it. From the examples we saw, we could try one of the following possible types of lists.

THEMATIC LIST

Like Lynda Barry in *100 Demons*, find a theme and make a list from there. If you mostly know your story already, then choose a theme from inside that story.

For instance, if you plan on telling the story of your many moves across the country as a child in a military household, you might make a list of "old experiences I had to experience anew." On that list you might include the obvious: first day in a new school, for instance, but maybe it helps you remember other details such as how many times you had to learn the layout of a new grocery store. Trying to find your favorite candy in each new place. Finding a new swimming hole or place to hike, etc. Whether or not you changed lipstick or hair color each time you moved.

TIME PERIOD LIST

Or like John Porcellino, make a general list of memories related to your specific time period. He sometimes tells stories about childhood, sometimes adolescence, and sometimes stories of his adulthood. (He also adapts other stories, usually traditionally Buddhist fables.)

Make this list slowly. Get yourself a separate book for each or get yourself a divided box of index cards and over the course of the next few weeks or years, add to each section as memories from that time emerge.

ANECDOTE LIST

Likewise, Chiappetta certainly must have had hundreds of other anecdotes about fatherhood to tell. He just dove in and told the ones that seemed most important.

More Than You Need

So make a list of potential episodes. Find a gathering category—a theme as did Lynda Barry, a time period like Porcellino did, a role or relationship like Chiappetta did, and make a list of potential topics. This is essential. You will probably need more than you will use.

GO FURTHER

WRITTEN EXPANSION

Take at least two of those episodes and write them in more detail. Include as many other memories that surround that topic that you can. See the next page for my example.

TELL IT ALOUD

My student Larry, a terrific lively storyteller with great stories, is working on a memoir. He recently worked up a few pages and, though they were good and fun, they missed a lot of detail. We asked him in class to tell us the story aloud, and out came a long, elaborate, incredibly detailed, strange, harrowing, and funny story. So many of these details weren't in his current outline or his first draft. We made him record this reading and create an outline from the recording.

Everyone should do this at least once. Tell the story aloud—what do you focus on? What events bubble up? Tell it in public, or in private, but speak it in an effort to gather material.

FOR FURTHER READING

If you want to go deeper with writing in this phase, I recommend Natalie Goldberg's book on memoir, *Old Friend from Far Away*.

Additionally, her *Writing Down the Bones* is a brilliant book about trusting your voice and finding inspiration, filled with page after page of great inspiration.

Other good resources are:
Anne Lamott's *Bird by Bird*
Lynda Barry's *What It Is*
Kenneth Atchity's *A Writer's Time*

Don't forget, this is the stage you might want to be gathering other resources, too. Histories, references, photos, even interviewing other players in the story.

LIVE EXAMPLE

In these sections, I plan to start a small memoir comic from scratch. As you read this book, this project will proceed in the same order and you will see me trying the same methods to make a realized, small final project.

FOREST STORIES

I am choosing the category "Forest Stories." I want to write about my early fondness for wooded areas, and maybe investigate why, after decades of city living, I seemed to have lost it. My thematic list, à la Lynda Barry:

Forest Stories:

1. The moldy chair in the woods outside our apartment complex, taking photos of it
2. Believing Bigfoot was right outside my window in the trees
3. Going under the bushes to hide, the kid who lit matches there. (Did I?)
4. Building a lean-to after falling in the stream, a quarter mile from home
5. Walking the Appalachian Trail at 19
6. Finding the house on the trail that put up hikers for cheap
7. Those massive power line pole structures that loom over the hills and forests
8. Driving through the woods to Kathryn listening to Pink Floyd's *Animals*
9. Taking photos of the big upturned wall of roots
10. Feeling *In Watermelon Sugar* takes place on the Appalachian Trail
11. The comic strip about walking deep into the woods to smoke cigars
12. Walking up Snake Hill with my grandfather—what a good idea
13. Climbing Overlook Mountain in Woodstock
14. The rock walls everywhere—who built them?

From here, I am choosing one and making a "written expansion" from the further exercises list, and hoping that those trains of thought will take me somewhere else.

Here's a writing I did from item #1, The Moldy Chair.

There was an old chair by the lake in the woods near my apartment building. I sought it out like a secret lover (though I never had a lover so young!). This would be 15 or so. It was left there—who left it? It never went anywhere. It was to my deep teen mind a sign of mankind's lazy intrusion into nature. Or something. I never sat in it. Did I? Let's believe I did. What I did was photograph it, over and over. Drawn to contrast, I took photos and photos. So people would see how deep I was. A chair in the woods. I sat on a rock and stared at it.

I don't know how much of that I will use, or if I will rewrite any, but it's good to get started. If I do this a few more times, I'll begin to cobble together a series of thematically linked images and, hopefully, stories.

CHAPTER 3

ORGANIZING MATERIAL

When we've got material—preferably too much—we can begin to look at the best way to structure it.

Let's remember that we have one important job: Keep the reader engaged. Sometimes we do that by infectious drawing, sometimes we do that by the wild events that we're telling, but more often than not, we do that by crafting a story.

People love stories. Stories are currency; we trade stories all the time. Good stories, short stories, long stories, funny stories, profound stories. Stories move us in ways that little else can; they give us empathy, and supply us with continuity that our own brains need to contextualize our lives.

So let's take our material that we've been gathering and begin to organize it into a story.

Again, let's look at three examples. These three are all childhood stories.

KAMPUNG BOY
by Lat

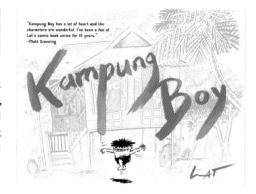

Kampung Boy (2006, First Second) by Malaysian cartoonist Lat is made entirely of short anecdotes. The drawing is wild, infectious, gregarious, and fun. The premise of the book can be summed up as "Lat grows up having fun in a poor village." He says about *Kampung Boy,* "We had become city rats and I wanted to tell people about our origins."

Two small threads weave through *Kampung Boy*—his delight playing with a set of three brothers from school, and everyone's fascination with the tin dredge outside the village.

LOOSE COLLECTION OF EPISODES

A look at the outline of his book (below) shows Lat moving chronologically from anecdote to anecdote, whether it's at the fishing pond or in the study hall, until he is grown enough to move to a neighboring town as a young man. It's loosely structured.

From a life of 10 or 11 years, he chose only between 18 and 19 anecdotes to tell. What keeps us reading is not the dramatic arc he has created, but the drawings, which are energetic, and the storytelling, which is rich and full of life.

KAMPUNG BOY OUTLINE

1. Birth and birth rituals in the village.
2. Playing as a toddler with sunbeams, and his first look at the tin dredge.
3. Making rubber at age 4.
4. Looking at the tin dredge, yelled at from Mom; Mom's fury.
5. Description of funny Dad, contrasted with Mom. Dad's knowledge. Driving with Dad.
6. Trips shopping with Dad.
7. Description of the town, social scenes, the train.
8. Beginning Koran studies at age 6.
9. Three friends from school, brothers, fishing.
10. Passing the dredge.
11. A wedding party of distant relatives. Dad dancing.
12. Age of 9. Class, a new brother, shopping on his own.
13. Discussion of his playing with the three brothers.
14. Life and school at 9. More fishing and passing time with the brothers.
15. Almost 10 years old, time for his circumcision.
16. Panning for tin outside the dredge. Scolded.

17. Dad takes him to his 2-acre plantation.
18. Passes school test. Will be sent to further his schooling in town.
19. Leaving for town.

THE END, unless you want to pick up the sequel, *Town Boy* (2007, First Second).

Note that the dredge (pictured below) appears three times in this chronology, establishing itself as one of the main forces in Lat's early imaginative development.

Lat by Lat

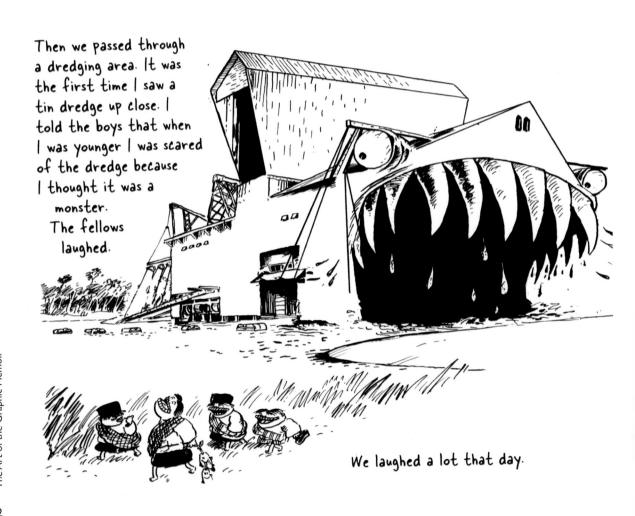

Then we passed through a dredging area. It was the first time I saw a tin dredge up close. I told the boys that when I was younger I was scared of the dredge because I thought it was a monster. The fellows laughed.

We laughed a lot that day.

NONNONBA
by Shigeru Mizuki

NonNonBa (2012, Drawn & Quarterly) by Shigeru Mizuki, on the other hand, is tightly structured and thematically grounded. The book is largely about his awakening to the awareness of spirits or *yokai* around him everywhere. He is aided by an old woman in the village, NonNonBa of the title.

TIGHTLY STRUCTURED PARALLELS

In between small anecdotes of NonNonBa instructing and testing young Shigeru, we also have at least 3 developing outside stories. One is the ongoing warfare of the neighborhood kids. Another is the father's career frustrations, his inability to progress in his city bank job, and his later opening of a movie theater in their small village. And another is the relationships Shigeru has with two young girls in the village, one who dies as a child, and another who is sold off as a geisha. His friendships with these two girls aid his spiritual visions, and he has one major vision with each girl.

The threads of the stories are so tightly controlled and structured that his second and final vision happens exactly one page prior to his older brother trying to hang himself from despair over a neighborhood girl. Likewise, the boy army story comes to a head as he gains more and more spiritual wisdom. All of these stories are tightly plotted to make the events seem more and more urgent as the book progresses.

Shigeru by Shigeru

Read these samples right to left!

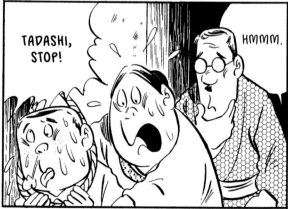

The reader spills slowly out of Shigeru's final vision, to be thrown instantly into a terrifying, urgent scene with his brother. (Read this right to left!)

WE CAN FIX IT!
by Jess Fink

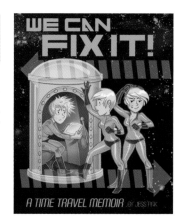

A third book, which is not chronological at all but starts with a thematic structure and then changes, is Jess Fink's *We Can Fix It!* (2013, Top Shelf Productions). Fink gives us the premise that her older self is going back in time to visit her younger self and warn her against embarrassing and hurtful situations.

WILDLY BACK AND FORTH IN TIME

Mostly in the beginning, older Fink is trying to encourage younger Fink to enjoy the sexiness of being young. But this wears thin on them both and eventually old Fink wants to protect the younger self in every situation possible. She jumps all around her own childhood, warning her against sending lewd photos to boys, buying ugly pants, indulging in bad comics, etc., until all of this intrusion into her past is seen as empty.

The book is compelling because the older, current Fink is the main character. We watch her increasingly frustrated with her own misperceptions with how she can change or interact with the past. The book is giddy and exuberant but also reflective as older Fink learns to appreciate all that younger Fink went through. It's magnificent fun and structured utterly unlike most memoirs.

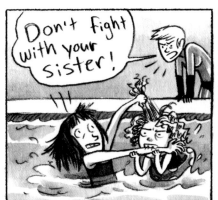

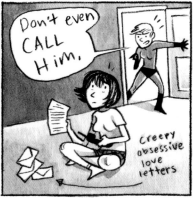

Jess by Jess

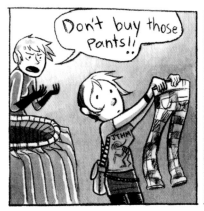

LEARNING IS THE KEY

In all cases, *learning* is paramount. Stories are almost always about learning. In *Kampung Boy*, the learning is slow and casual. In *NonNonBa*, it's more rapid, guided by a mentor's hand, and in *We Can Fix It!*, it comes about late in life, after reflecting.

But it was about this time that I suddenly discovered emotions I never knew I felt.

I felt sad...

Lat has learned!

Fink has learned!

I WAS EXPRESSING YOUR MENTAL STATE NOW WITH MY UNDERWEAR.

I THOUGHT YOUR UNDER-WEAR WAS A PART OF YOU.

SOMETHING YOU THOUGHT WAS A PART OF YOU HAS SPLIT AWAY ALL OF A SUDDEN.

AGAIN WITH THE RAMB-LING...

Shigeru, too. Read this one right to left!

MY STORY

FROM PLACE TO PLACE, FROM TIME TO TIME

In my case, since it was kind of a travelogue, there was a governing structure of the places we went to. The story went from place to place, with new events and people and thoughts coming at every location.

But in some cases, events that happened in a certain section didn't fit in their right time.

This one (*right*), which happened early in our experience, for instance, was the wrong mood for the tone of the rest of the chapter that documented that period, which was somber and desolate.

So I put this scene on the back burner and used it as a flashback later. It gave me the springboard I needed to go into the ending of the book—through Rosalie's name—but this wasn't the plan. I was guided by tone and mood.

When I realized how well it would work in that context, I kept it happily on reserve until it came time to draw it.

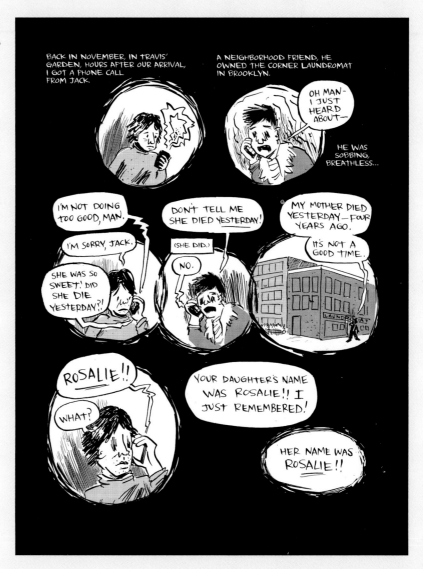

ALLOWING JUMPS FORWARD IN TIME

And though I included lots of flashbacks into the past, it wasn't until the panel below that I realized I could casually refer to the future, and I did so a number of other times, in cases where I needed to detail something small that was screaming to be mentioned, but not necessarily dramatized.

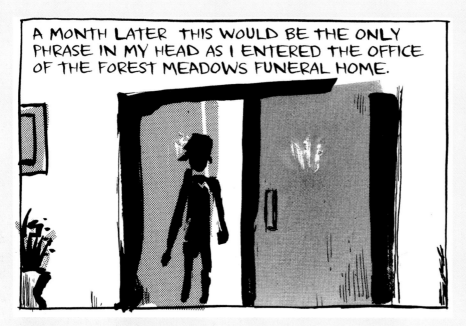

So this allowed me to follow these trains of thought, which moved from events to associations and back again, rather than adhering to chronology.

Since the book is so full of uncertainty and questions, I honored these natural paths the brain takes as the best option for structuring the material, believing that it would hold together.

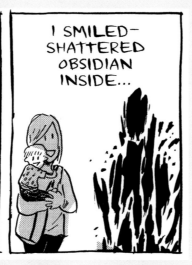

But I also came armed with a knowledge of traditional Western story structure, some ideas about mythic journeys, etc. The fact that my life events followed a lot of these made it natural to emphasize some of that underlying structure and mythic elements: the rupture of the old world, the entry into the new world, the guardians of the thresholds, the dark caves, the mentors and visions, etc.

Underneath it has a simple mythic structure, but on top it's digressive and organic. The book shifts from real events to thoughts about those events, to similar events in movies, stories, books, and even images in my own imagination.

STRUCTURE

Structure can sometimes change mid-project. When I was 50-60 pages into my book, I tried to describe its structure for my publisher. I described three significant sections in the book.

The Present: The 6 weeks from Rosalie's death in November 2011 to January 1, 2012.

The Past: New York to Gainesville: the story of our move from New York City to Gainesville, Florida, from January 2009 to September 2011. Though we planned for more than 2 years to move, Rosalie lived only 10 weeks there, and seemed enormously happy.

Essays, diversions, and poetics: These sections examine metaphor, imagery, and ideas and grapple with events and contextualize them—trying to understand the impossible to understand.

The division between these categories is somewhat fluid. Two of them are timelines containing the main story. The third contains poetic, philosophical, spiritual, and formal inquiries.

The above is an accurate description of the book. Categories 2 and 3 begin the book, interweaving semi-equally with occasional intrusions from The Present (Category 1). After chapter 5, the book becomes mostly about (1), The Present, with the "essays, diversions, and poetics" (3) weaving in and out, mostly through the caption boxes.

THE STORY ARC

Agents, publishers and producers always want to know the story arc. And most readers will respond to it, too.

Earlier in this chapter I said "learning is the key." The story arc is about this learning.

What do the characters learn? How do they change? If they are one way in the beginning, how are they different in the end?

To help myself find that arc, I asked what the characters (my wife and I) wanted. I answered with the following:

What the characters want:

- Messages from Rosalie
- To see her, to sense her still there
- To find her and raise her
- To turn back the clock, to go into the past
- To not hate seeing the moon, and the stars, and the other beautiful things she loved and they shared.

These questions became guides to making sure that the "present" sections had a unified focus. A lot of events were dropped from the original outline because they didn't contribute significantly to the characters' wants and needs as stated above.

And then I asked: How must they (meaning us, in real life) change?

- They must come to a new relationship with Rosalie.
- They must become free of denial.
- They must work with Rosalie's power to help them look forward.

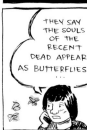
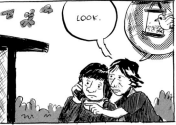

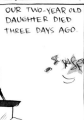

Early drafts trying to figure out the emotional ending.

In the pitch for my book, I supplied 40+ pages of the beginning, but also 4-5 later pages, so that readers could get a sense of the arc and how the characters change. Envisioning the arc and the change was a good exercise to help me stay focused.

The images at left are initial designs from the original final section, which were somewhat changed for the final book.

The question in this panel was one of the overt phrasings of the book's themes within the book itself.

ON LYING FOR MORE EFFECTIVE STRUCTURE

You'll probably find yourself needing or wondering if you should fudge the chronology to make the structure more solid, to make the arc more consistent.

I'll share two examples, one gentle fib, and one other I considered making but thankfully didn't.

This first is this intense crying jag (right), which happens on page 139.

In reality it really fell in section 5, marked with black pages and tiny staccato drawings. Unlike the quick, shocked moments in this section, I wanted to extend this one and felt that it was best shown later. I didn't exactly say this happened much later, I just didn't not say it. A gentle fib, hardly scandalous.

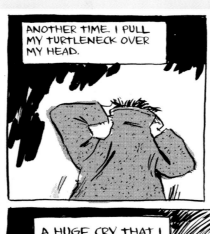

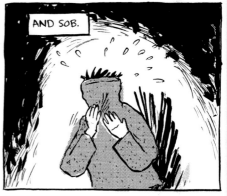

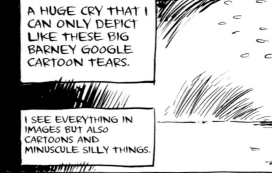

Here is another scene that at one point I considered moving back in time, because its negativity would have been more consistent if placed earlier. The trajectory at this point in the story is clearly one of healing. But I left it where it really happened, since I felt as if it would be okay if this episode seemed like a step backward, a sort of wobble in the arc.

But in fact it also sets up the more shocking two-page sequence that begins immediately after, so in the end, the placement was right.

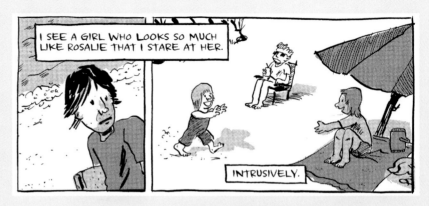

I SEE A GIRL WHO LOOKS SO MUCH LIKE ROSALIE THAT I STARE AT HER.

INTRUSIVELY.

IN ITS FINAL CHAPTER, PALOMAR, TO FREE HIMSELF OF THE DIFFICULTY OF LOOKING, THINKING AND BEING, BELIEVES HE MUST "LEARN TO BE DEAD."

I TURN MY BACK TO THE SUN AND PRACTICE.

THE WORLD EXISTS WITHOUT ME.

DO THIS

Let 's take at least five items from our previous list and write them briefly onto index cards. From there we'll try three organizing principles based on the examples we saw in this chapter.

CHRONOLOGICAL

Let's organize them chronologically like *Kampung Boy*. Let's write out an outline that features each anecdote in sequence.

MULTI-LAYERED

Let's organize them chronologically but intersperse three other cards. These three cards should represent key moments in a larger external story. Maybe it's something going on in the family at the same time, or maybe in the world of politics, or even something fictional that has resonance. Perhaps you will recount key moments in a book or a movie that you encountered at this time. These three or so other cards should be inserted chronologically into points in your outline, like the many intertwined stories in *NonNonBa*.

SHUFFLED

Let's take five or more cards and shuffle those cards randomly. That will be our outline. Construct simple narration or a complicated story device like Fink's time-traveling to connect the events.

GO FURTHER

USING MISDIRECTION

Josh Bayer, whose *Theth* was discussed in section 1, was interviewed about using the event of John Lennon's death as a focal point for his story, even though his story in real life didn't happen during that exact time.

> Bayer says:
> *It's an act of deflection on the author's part, like me saying, "Hey look over there" because I'm not gonna just write about how hard it is being a little kid living in Ohio feeling bad. Sure, that's what it's about, but I'd rather use misdirection to properly tell that story....I'm trying to run in the other way from that because there's a million stories about little lonely kids in Ohio. And there's a million interesting things to juggle in for the characters to feel numbed about. Everyone in that story is pretty numbed out.*

So for our exercise, let's use misdirection. What outside event can the characters in the story be affected by?

EXAMINE THE LEARNING

In the previous section, we point out that learning is essential in any story like this. In your own piece, examine what learning happens. Once we look at what that learning is, how do we want to highlight or show it?

For the sake of our exercise, let's try three variations:

1. Put it at the end as a reflection, as in Jess Fink's book. Try a panel or two of your character reflecting, even out of frustration. (The TV show *South Park* always pokes fun at this method of structure, having a character talk to the camera at the end about what he or she has learned.)

2. Introduce it right away as a sort of test. Maybe a character sees a model of behavior, or the reader knows more than he or she does early on. Or maybe narration carries it early on. Either way, we understand what must be learned, and we then watch the characters learn it.

3. Highlight in your outline only the sections that are about the larger learning and omit everything else, just as an exercise. Not all stories need to be so tight and single-minded, but it's worth examining what's carrying the weight of the arc.

FOR FURTHER READING

There are lots of great books about writing, most of which have sections on organization and structure. Some of my favorites:

The Art of Dramatic Writing by Lajos Egri
Story by Robert McKee

Impro for Storytellers by Keith Johnstone
On Directing Film by David Mamet

LIVE EXAMPLE

If we've begun gathering, we can play with organizing, with the idea in mind that material always changes when we begin to shape it. If we don't want it to change substantially, then perhaps we just find a chronological thread and stick with it. Otherwise, we can try some fun strategies from the previous page. My working examples:

CHRONOLOGICALLY

1. *Building a lean-to after falling in the stream, a quarter mile from home*
2. *The comic strip about walking deep into the woods to smoke cigars*
3. *The moldy chair in the woods outside our apartment complex, taking photos of it*
4. *Driving to Kathryn through Sawkill listening to Pink Floyd's* Animals
5. *Walking the Appalachian Trail at 19 with Brett*
6. *Taking photos of the big upturned wall of roots*
7. *Feeling* In Watermelon Sugar *takes place there*

CHRONOLOGICALLY WITH OTHER LARGER PLOT

1. *Building a lean-to after falling in the stream, a quarter mile from home*
2. *The comic strip about walking deep into the woods to smoke cigars*
3. *The moldy chair in the woods outside our apartment complex, taking photos of it*
4. *Driving to Kathryn through Sawkill listening to Pink Floyd's* Animals
5. *Walking the Appalachian Trail at 19 with Brett*
6. *Taking photos of the big upturned wall of roots*
7. *Feeling* In Watermelon Sugar *takes place there*
WHAT to add? More about my friend Kathryn? My friend Brett? My grandmother's Alzheimer's disease? My daughter's impending arrival (30 years later)? Comics I was reading?

SHUFFLED

8. *Driving to Kathryn through Sawkill listening to Pink Floyd's* Animals
3. *Going under the bushes to hide, the kid who lit matches there*
13. *Climbing Mt. Overlook in Woodstock*
1. *The moldy chair outside our apartment complex, taking photos of it*
9. *Taking photos of the big upturned wall of roots.*

LIVE EXAMPLE

MISDIRECTION

A lot of these events happen in childhood or teenage years, the early-mid-late '80s. AIDS, cocaine, pop music. Also a lot of the ideas/images in this section are about retreating from society. What larger event could provoke this? The *Challenger* crash? The fall of the Berlin Wall? The coming of the Internet? Something smaller? A parade? A new restaurant opening? The new mall?

EXAMINING THE LEARNING

At this point, all I think is that the learning here at least includes "we change as we get older." Or perhaps, "we move away from our early obsessions...." I could put this up front in an early draft, or just use it as a guidepost to guide me later. But the truth is, I'm beginning to suspect something else is going on. My friend Kathryn—mentioned many times in the outlines—I haven't heard from in ten years. Where is she? Could I plan to learn that?

CHAPTER 4

FINDING A VISUAL STYLE

Style can mean a couple of things. It can mean your innate visual voice—the way in which your hand, eye, and mind work together. You can train these, of course, like you can your throat, your lungs, and your vocal chords to sing, but many of its qualities may be innate or may seem immutable.

Style can also mean stylistic shifts. Heavy lines, light lines, no lines, bright colors, dull colors, that sort of thing. Variation within our range.

Since the former is a matter of innate qualities plus practice and training, and the subject of many drawing books, we'll concern ourselves with the latter here.

Which types of renderings and techniques might best serve or augment the story? Which styles might prove an interesting counterpoint? Which techniques say something about the story in the direct responses they incur in the reader?

We'll look at three examples; these three are about love affairs.

GRAFFITI KITCHEN
by Eddie Campbell

SPONTANEOUS AND SOMEWHAT MAD

Eddie Campbell, in an intro to his *Graffiti Kitchen* (1993, Tundra Publications), talks about waiting for years to draw it while waiting to figure out the right style. "It demanded a different style," he says, "a more spontaneous one, more intimate, if somewhat mad."

And it *is* these things. The drawing style is fast and urgent—it feels like an expulsion. He says the book took him a few weeks to draw.

In the opening panel from the book, Campbell the narrator says, "Watch me. I'm the most important guy in this bestiary." The drawing is quick and loose, he draws himself bulky and hunched with energy. Aside from the hatching on his pants, the most consistent grouping of lines are the ones that theoretically make up the wrinkles on the arms of his jacket, but they more resemble the coils of a spring.

In the next panel he says, "I walk with a forward tilt and cut through brick walls with my beak! But here I am adopting the human position to listen to a drunk named Jimmy Fulton." There, some dialogue kicks in and we watch the beginning of a mini-drama.

Through the words and drawings in these quick two opening panels, Campbell instructs us how to read the book. Watch me, watch the scribbly lines, watch how the lines assemble themselves into characters and morph energetically from one form and one scene to another.

Alec by Eddie

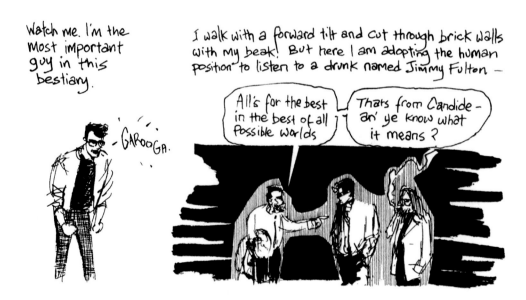

THE CARTOONIST'S VOICE

Campbell, referring to his earliest autobiographical Alec work, has said, "When I eventually started page one, I didn't know if this was another false start. I was probably a good 20 or 30 pages into it before I knew I had found the voice I was looking for."

And about a cartoonist's "voice" he says, "All of the elements of a comic strip—the panel, the balloon, the particular style of caricature—all of these are combined in particular ways to form a voice. I think every cartoonist at first is moving the parts around to find the voice that is their authentic voice."

In *Graffiti Kitchen*, ink lines from one panel tend to dissolve and hurriedly reconfigure in order to form the next one.

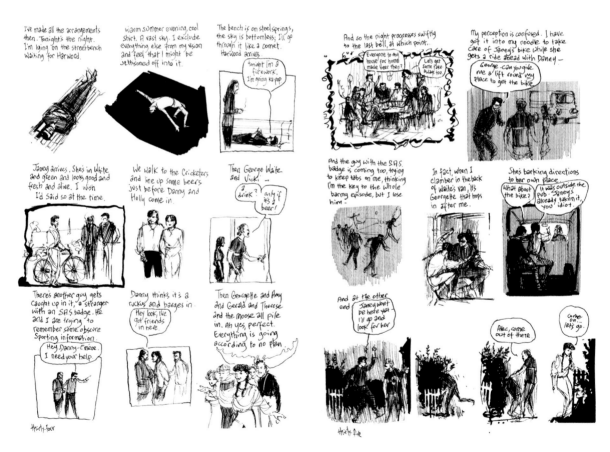

A typical spread from *Graffiti Kitchen*, showing the energetic way in which the drawings are assembled from ink and line, within a consistent nine-panel rhythm with text captions leading atop each panel. It has the effect of a series of very steady bursts of energy.

DAVID CHELSEA IN LOVE
by David Chelsea

DETAIL AS AN ACT OF LOVE

Compare *Graffiti Kitchen* to another memoir about a love affair, *David Chelsea in Love* (1993, Eclipse Books) by David Chelsea. Chelsea showers every moment with a slow, methodical, visual attention in a variety of different styles.

The book documents a bicoastal affair with Minnie, a hard-to-pin-down actress who doesn't know if she wants to be with David or not. Nonetheless David is obsessed, and his drawing shows this obsession: little dots of stippling, loads of detail in backgrounds, clothing, and expressions. Through the visual style the book celebrates the awkwardness of the whole affair.

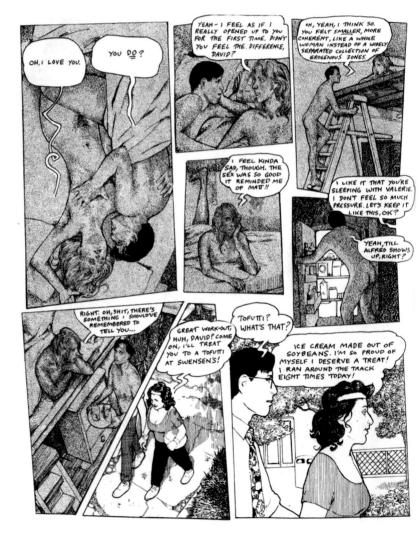

There's a significant style shift here even as the structure and composition of the panels stay the same, as David moves from woman to woman.

In trying to get every expression correct and being so deliberate in rendering every hand, body, person, and environment, Chelsea is casting a magnifying glass on his past, celebrating the quirks and awkwardness of youthful indecision.

David by David

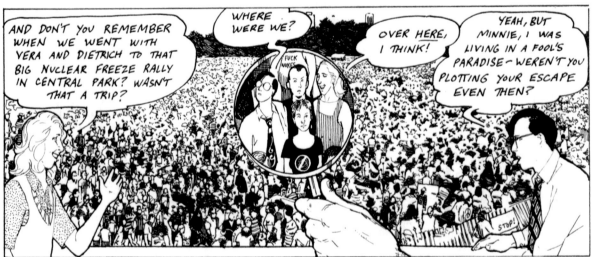

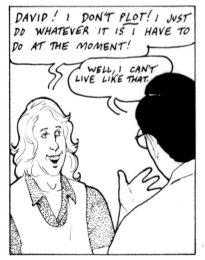

Chelsea offers high amounts of attention to fabric, patterns, light and shadow, and characters' expressions in the service of expressing the past.

DANCE BY THE LIGHT OF THE MOON
by Judith Vanistendael

FLOURISH AND GRACE

Judith Vanistendael's *Dance by the Light of the Moon* (2010, Selfmadehero) is a graceful, elegantly drawn "semi-autobiographical" homage to an early love affair in her life with a refugee from Togo. She draws in fluid, elegant brushstrokes, her characters drawn with warmth and humor. She draws loving and sexy parts with grace and passion, while frightening parts about political unrest or torture are drawn with a scary expressiveness.

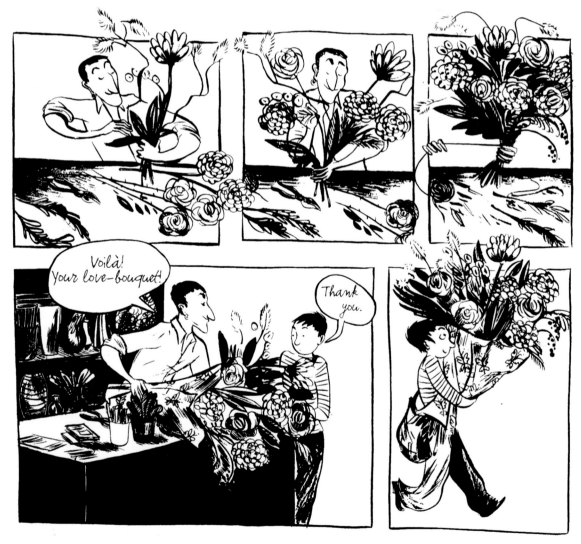

Vanistendael's drawings are lush and full of life, as can be seen in this bouquet from the florist.

FINDING A VISUAL STYLE

Sophie by Judith

How we draw affects the mood and the impact of our piece. We can't all be masters like the three artists we just saw. In fact, visual style is often something we have little control over, like the sound of our voice.

We can enhance what's there, or learn new techniques, but often we stumble into our style.

What tends to happen is that if we're present and draw from observation, our style finds us. We may strive for something, fail to hit the mark, and then find ourselves having drawn something else that is more uniquely us. We notice later that our mark-making—our drawing—is how our hands interpret the visual world right now and that's fine.

As we get more advanced, we can look for more complicated styles, like Eddie Campbell did, or choose a particular technique, like David Chelsea, or even just bring a huge and practiced gracefulness to the page like Judith Vanistendael.

But in general, we should just work honestly through observation and practice to try to tell our story.

Drawings of war and torture are drawn with the same clarity, drama, and expressiveness.

FINDING AN APPROPRIATE MODE OF EXPRESSION

I spent most of my career drawing silly pictures. Humorous farces and comic strips—characters with big noses and big feet. It was all I really was capable of drawing, and since it lined up with my interest in social satire, I kept developing and refining this style for almost twenty years.

None of that seemed right when suddenly I had to tell a tragic story. It was somehow fun to draw my little daughter in a light and cartoony way, but everything else needed a more serious tone to it.

Tragedy not being my forte, I sketched when I could, learned to use a brush better from my friend Justine, and eventually, just went for it. Sometimes scratching with the pen like my life depended upon it, which in some ways, it did.

Since I'm not well trained in serious expressive drawing, a lot of this effort came hard, and ultimately the drawings fail to convey what I wanted. Sometimes, I hope though, that the desperation is visible in the drawing, like maybe you can see the struggle to get the picture out, there inside the picture itself.

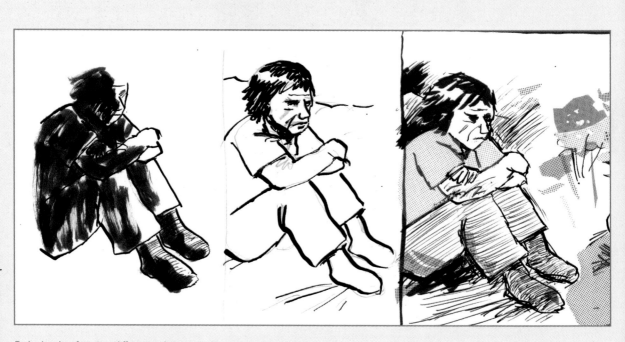

Early sketches featuring different styles.

SHORTCOMINGS

I grew tired of drawing cars and sometimes gave up, implying their shape with shading film. Other drawings I did over and over again to get right and never did.

I grew tired of drawing people, the same people, with specific expressions on their face. At some point, I realized I couldn't draw these people—my wife and I and the people around us, as if they existed in reality and I was just transposing it.

I began to feel that this story happened in a more ethereal or mythic space, and as I became more confident in believing that this was true, some of my more appropriate—and less literal—drawings came out.

To sum up, I tried my hardest to do what was right for the story, but had to forgive myself the shortcomings I brought with me. I did the best I could, hoping it would resonate. I expressed what I could, learned a lot, and came out a different person.

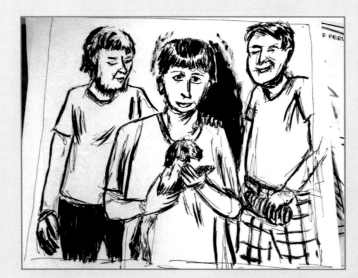

SKETCHING

I did lots of sketching in certain places, just to understand better the image I was trying to convey, whether it was these three boys holding a baby goat, or a fictional character in despair, or our own trauma, or just a couple of wild chickens.

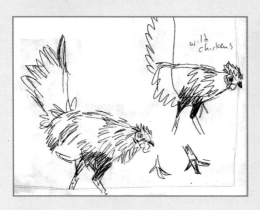

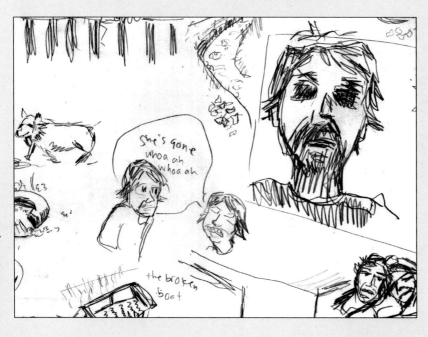

MENTORS AND MODELS

I also went to friends and mentors for help. Below is an inked tracing of a drawing by my co-teacher at SAW, Justine. She is an expert with a brush, and I asked her to show me how she might handle some of these drawings. My drawing that follows is more my own, less controlled, frankly, and more crude, but maybe more me in a way that I hope is effective.

Additonally, some of of my visual inspiration came from the EC Comics that spoke to me during the time of the events. I copied them literally at times, then tried to remember the style and motion of the pen and brush when making other drawings.

The mud on the road (bottom), for instance, was done thinking about the mud in that deep Johnny Craig hole (below).

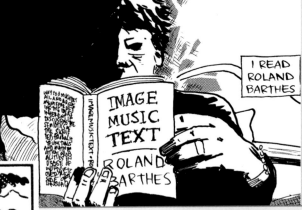

CARTOONING

For whatever reason, the one visual style in the book that should have been easy was depicting my wife and me as simple three-head-tall cartoon characters on a lifeboat.

In fact, virtually each one of these drawings is quite terrible and I am utterly displeased with them! I couldn't draw them on a large scale. The few instances where they needed to be squeezed into a tiny panel they work fine.

Another drawing I was displeased with is the third panel in this sequence. I am attempting to literally copy the cover to Josh Bayer's *Raw Power*, and succeed the first time in panel 2, below. But in the next one, I missed the tension in the shoulders, and it comes across as a calm rather than a vicious slicing across the chest.

A drawing is sometimes a performance, and I came to like this slightly imperfect one, so I left it, as a sort of waver in my voice. Perhaps it's an unconscious foreshadowing of the calm we needed to arrive at at the end of the book.

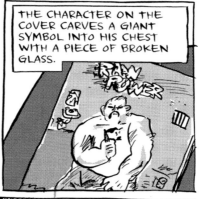

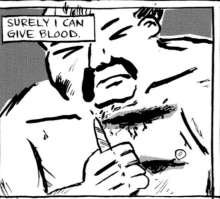

DO THIS

The best things you can be doing in this section are *looking* and *experimenting*. Look at the material of your story, yourself, your family or friends, the important artifacts and objects in the story. And experiment visually.

LOOK!

This is a good time to collect visual materials: photos, references, inspirations. Put them in front of you, study them, and let that looking become a part of the engine that is driving this story.

And then we can start drawing in order to look at our materials better. Here are a few ways to make sure you are *looking* at your materials. (Remember your friends and family in real life may be some of your materials, too. Don't be afraid to draw from life.)

* **Trace a photo.** This will also help you to see it while you worry less about whether or not you're "getting it right."
* **Draw it upside down.** Not hanging upside down, but if you're looking at a photo, then turn the photo itself upside down. Your mind will be tricked into seeing lines and shapes more than objects ("a nose," "an eye," "a wheelbarrow," etc.). You'll find yourself understanding the visual terrain of the source material more.
* **Draw it with your nondominant hand.** Like working upside down, this forces you to go more slowly, comparing what your hand is doing with what you're seeing often.

EXPERIMENT!

Find a sketchbook or just a stack of papers and start sketching. A sketchbook is a place to experiment, and, more important, to fail.

Play around. Try three different styles. Choose from:

* Scratchy
* Clean
* Realistic
* Stippling (lots of tiny little dots and marks)
* Humorous

Try a few different techniques:

* Watercolor
* Pen and ink
* Pencil
* Digital
* A too-big brush
* Your nondominant hand
* Collage!

Exercises

GO FURTHER

LOOK AT MASTER WORK

The complementary act to our looking and experimenting is studying how artists have solved similar problems in the past. Go to masters, not peers, and look for solutions and choices. Try to see what they were seeing when they rendered their work. We want to mimic it at first, but then integrate it into our own voice and storytelling.

For this assignment, copy and/or trace at least one drawing of the subject matter you are addressing.

TAKE A WORKSHOP

Just get started in a medium or technique by taking a class. You'll have access to that when you sit down to make your memoir. Whatever you learn, whatever practice you've picked up, whatever muscle memory you've created will be there. Try it!

FOR FURTHER READING

This list of books begins with general books about seeing, and moves onto a sampling of specific techniques you might want to explore.

The Zen of Seeing: Seeing/Drawing as Meditation by Frederick Franck
Drawing on the Right Side of the Brain by Betty Edwards
The Encyclopedia of Art Techniques edited by Tessa Clark
Rendering in Pen and Ink by Arthur L. Guptill
Urban Watercolor Sketching: A Guide to Drawing, Painting, and Storytelling in Color by Felix Scheinberger
How to Draw Noir Comics by Shawn Martinbrough

LIVE EXAMPLE

I found old photos from a hiking trip in 1989 or 1990. I traced one, right. Tracing it allowed me to not worry about getting it right, or concerning myself with the shapes and compositions, but just allowed me to focus only on rendering and on gentle tweaks, like de-emphasizing the darkness on the left side, for clarity.

Later, I found in my endless piles of scraps and references a panel clipped from a twenty-year-old manga. I have no idea who did it, nor what the Japanese text says. But I love how it created depth from the solid blacks in the distance, and I wanted to understand that as well as how it dealt with the clutter of all the birch trees in the front. So I decided to redraw it.

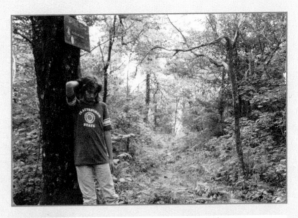

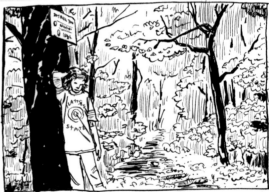

This image was traced.

This image was copied.

Finally, I looked at Bill Watterson, master of cartoon trees, and clipped one drawing that I copied to get a sense of how he used white on top of black, as well as how he created organic patterns of leaves and branches.

Bill Watterson's amazing trees.

Exercises

71

As I write this, lucky for me, a "draw in the forest" workshop is being offered by an amazing painter in town. It focuses on walking through a semi-burned pine forest and then drawing it using a variety of lines.

Below are some scenes from the workshop and one of my sketches.

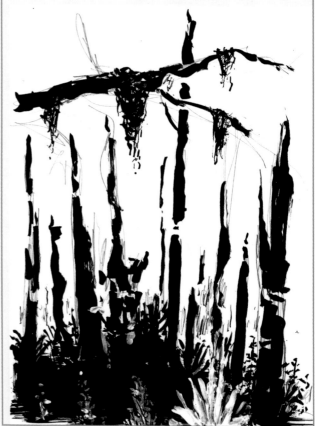

CHAPTER 5

STARTING

If you've made it this far, and have done the assignments, then you're probably ready to start.

A lot of us can overprepare (I'm one of them), stalling ourselves from really starting.

Starting and working is scary! We think: *What if I'm not good enough? What if my story is dumb? What if no one likes it?*

These internal critics are our biggest enemies to actually working on our book, so sometimes we need to trick them while we get our courage and some momentum up.

One way is to give ourselves simple tasks, focusing only on the present. We're going to look at three artists who have created amazing large-scale bodies of work by focusing on the day-to-day.

HOW TO UNDERSTAND ISRAEL IN 60 DAYS OR LESS by Sarah Glidden

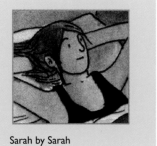

Sarah Glidden was an art school graduate with a painting degree, and an interest in photography and drawing, when she realized that she wanted to try comics.

NEW DAY, NEW COMIC

So she started. One a day for eight or nine months. Silly little things, about finding a seat, being bothered by a fly, or affected by the heat or the cold. In these little strips, she observed, documented, and experimented.

And day by day she tried something new and taught herself the comics form.

She published these as series of small mini-comics, and then when she felt she had said enough and done enough work in that mode, she created a longer, semifictional story as another experiment.

And with that work under her belt, she went on a long journey with the thought of turning this real-life journey into a graphic novel.

How to Understand Israel in 60 days or Less (2011, Vertigo) became a series of well-written and well-drawn black-and-white self-published mini-comics until an editor at Vertigo comics saw it and offered her a contract to publish it in full color.

Sarah by Sarah

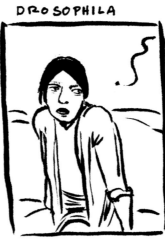

DROSOPHILA

THE FRUIT FLIES WHICH HAVE INVADED OUR APARTMENT

HAVE TURNED ME INTO A CRAZY MONSTER.

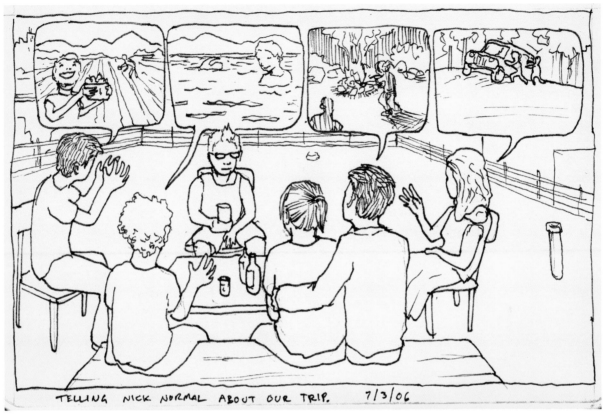

A quick, experimental comic in a sketchbook from Sarah Glidden's early diary comics.

Which she did. 200 pages, fully watercolored, and like the fable of *Stone Soup,* this all happened from starting with a simple daily diary comic.

Samples from the early and later version of *How to Understand Israel in 60 Days or Less*

MAKE ME A WOMAN
by Vanessa Davis

FRAMES FULL OF LIFE

Vanessa Davis started by making little visual diaries of her life. Sometimes one-panel, sometimes two, usually fewer than four. These comics were less about experimenting with form and were more about Vanessa establishing and developing her utterly unique and lively personality on the page.

Each day Davis retold a quirky, often self-deprecating moment from life in her *Spaniel Rage* comics. These had a charm and sense of humor that no other diary comic had.

From there, Davis went on to tell only slightly longer stories, usually no more than three pages, but packed with funny moments, light and big-hearted drawing, and tons of personality. She collected her best stuff into *Make Me a Woman* (2010, Drawn & Quarterly), as whole and complete a memoir as anything more structured or preconceived.

Davis's stories highlight the strength of your voice as a structural force.

Davis established her work and her voice piece by piece; one strip at a time, often one panel at a time.

December 26, 2003

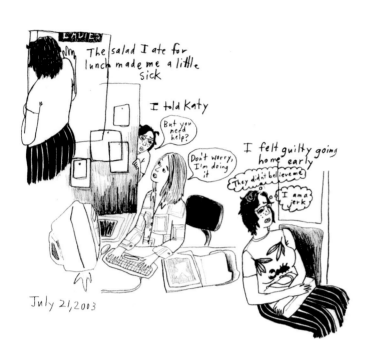

Vanessa by Vanessa

In Davis's early work, she worked with loose page structures, *(right)*. Later, she structured her pages more tightly to allow more involved stories to flow.

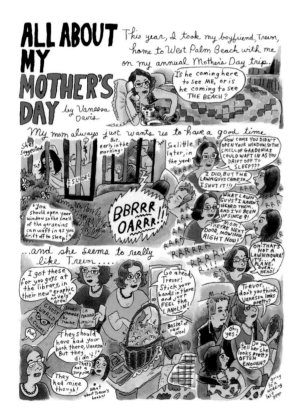

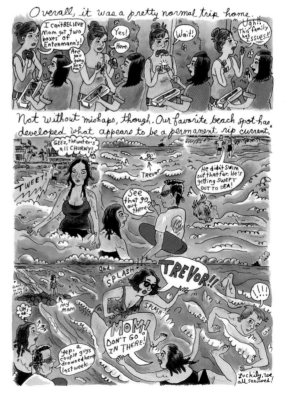

JULY DIARY and Other Works
by Gabrielle Bell

RAW COMMUNICATION

Gabrielle Bell started making comics about her simple day-to-day life early on, but as the years went by, her comics became more and more raw, and more about desperation, intense alienation, and loneliness. They even began looking more raw—she started adopting a style that makes it look as if she's scraping skin and texture off of everything and everyone. Bell's comics are so bare that you can almost miss how intelligent and witty and even funny they are.

For instance, she occasionally ventures into "fake autobiography," where the story veers off in an improbable direction that only reveals itself as improbable once you're fully in it, as she did with a story about supposedly adapting Valerie Solanas's famous *SCUM Manifesto*, or the page left, where she imagines herself suddenly with a husband and family.

Gabrielle by Gabrielle

JULY DIARY

Every July, Bell makes her "July Diary." She's said that in that month, she, who is ordinarily reserved and reluctant to leave home, makes sure to agree to any request to go try something, or to go see an event or go hiking, etc. She chooses this month to be alert to the world, and to record the results for her journal. The sample of first panels below show the depths she explores even when she does barely leave her house.

Bell starts with one event, one incident, one day at a time. Through her honesty, vulnerability, and wit, she became one of America's top cartoonists.

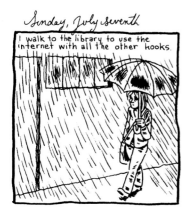

Sunday, July seventh

I walk to the library to use the internet with all the other hooks.

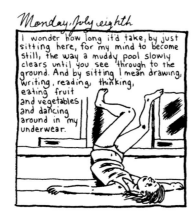

Monday, July eighth

I wonder how long it'd take, by just sitting here, for my mind to become still, the way a muddy pool slowly clears until you see through to the ground. And by sitting I mean drawing, writing, reading, thinking, eating fruit and vegetables and dancing around in my underwear.

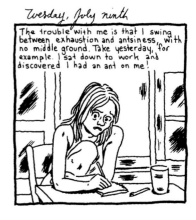

Tuesday, July ninth

The trouble with me is that I swing between exhaustion and antsiness, with no middle ground. Take yesterday, for example. I sat down to work and discovered I had an ant on me!

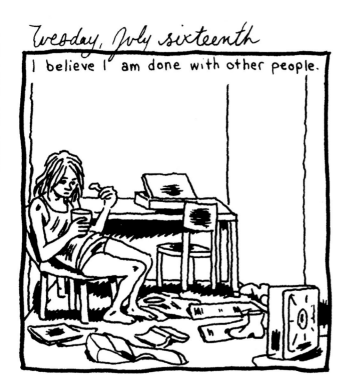

Tuesday, July sixteenth

I believe I am done with other people.

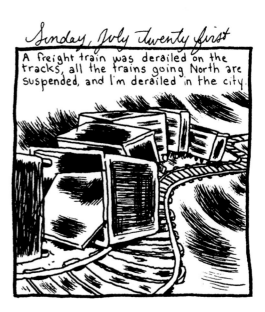

Sunday, July twenty first

A freight train was derailed on the tracks, all the trains going North are suspended, and I'm derailed in the city.

DAY BY DAY

So like Bell, Davis, and Glidden, just capture one event, one sequence, or one moment, and share it. There is immense satisfaction in that. And then do it again, and again. Soon you'll have the momentum to keep going on that big project you've been planning, or on more day-to-day pieces that will work together to reveal a larger, unified you.

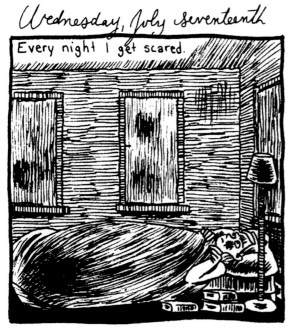

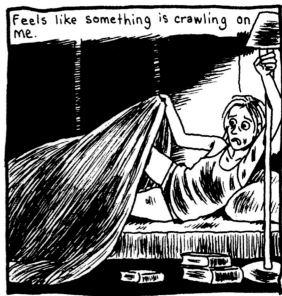

STARTING WITH WHAT YOU KNOW

My case may not be so relevant here, because this is one of the few projects for which I had no fear of beginning. My life was upturned. I turned to writing and drawing for my sanity.

I didn't have it all mapped out. I knew the events of the past and the present when I started writing, but I didn't know the structure, I just knew I had to make this thing.

And so I started with something, and by saying what I was starting with: Rosalie's favorite image.

I knew the book was about images, and starting with hers connected me to her. I knew I had to get from my feelings about her to she and I sharing the same space— an ethereal or spiritual space. I had to start with her, not me. Her and her imagination.

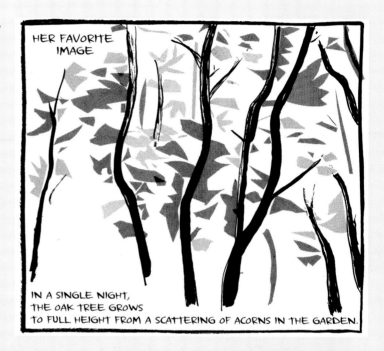

And every time I hit a wall, I would start a new section. I would go back to my list of ideas, dreams, and essays, or go back to the present moment or to the recent past—back and forth, through these three tracks, until a sort of overture was done, and the past events caught up with the present events and the book took on a new urgency, roughly seventy pages in.

At that point, I think I shared what I had, both by printing them up and by posting it online. Positive comments from friends kept me going as I moved forward.

I wrote a note above my desk, "Nothing matters except you have to tell this story."

And so that's what got me going. Working on it, and letting people see it in process.

The cover of the first self-published photocopied mini-comic.

TAKING A TEST RUN

As I said, I had no difficulty in starting this project; it kept me sane in a time of anguish.

But some specific things helped me.

One help was my early use of shading film. It's very trance-inducing, and also helped ritualize the process of working, and deepen the physicality of it, too.

But what was more important, like Art Spiegelman and Carol Tyler (whose stories appear later in this book), I made a story before the story. This one was in response to a call for homage stories to the Japanese alternative anthology *Garo*. I have always been inspired by *Garo*, and looking over my shelves of them, I thought I would do something I've always wanted to do: Take a story I can't read and create my own words for it.

I first found a story whose style I felt comfortable mimicking. Choosing it supposedly for its visual simplicity, I was stunned later that the story had such resonant imagery.

The piece follows a old man's younger self as he recounts losing a girl he meets in a village. I don't know more than that. My version became a hymn to my daughter, and a preparation for getting into the mindset I needed for the bigger book.

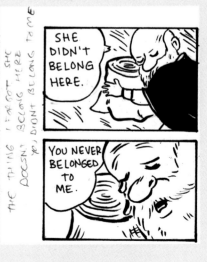

I have no idea what this story is really about, so I turned it into my own.

DO THIS

All of these assignments are designed to get you started. Let's just get moving and break past that blank page. Peter Elbow, in his book *Writing Without Teachers,* encourages us to start with "the wrong ideas in the wrong words," arguing that starting and giving yourself something to edit as raw material is better than expecting a perfect first draft from the get-go. I agree. We can obsess too easily about a book so much that it will never happen. Or we can create something—piece by little piece—that inspires us to move on with a little effort and revision.

DIARY COMIC

Put yourself back in the time of the story, and make at least three diary comics of that time. Do this just like you might in the present, about anything—crossing the street, eating a meal, walking around town, an argument at home. Don't worry about it being important to the story, just let it transport you to the universe of the story to get you started.

FOR FURTHER READING

Here are some good books about starting small:
Bird by Bird by Anne Lamott
Writing Without Teachers by Peter Elbow
Wild Mind by Natalie Goldberg
Old Friend from Far Away by Natalie Goldberg

GO FURTHER

FICTIONAL DIARY COMIC

Take inspiration from Gabrielle Bell and create a fake diary comic. Let it spiral out of control as your imagination takes over. Focus on your greater themes as you produce it. This imagined other life might serve you as you develop your longer piece.

COVERS

Daydream, think ahead. Draw future or possible covers for your book. Then create the comic that belongs inside. That cover is waiting for you!

WRITE A SCRIPT

Maybe now is the chance to write a potential script. If you're more word-focused, as I am, you may find that this is a useful way to get the cobwebs out and see if the story is becoming clear as we've been preparing to get to work. I write scripts a few pages at a time. Maybe that will work for you.

MAKE A SHORT STORY

Make a quick comic about the project. Assume that it won't be a part of your later project, or that it will have to be significantly revised.

A lot of large projects start as a small idea that is developed that way, and then again into a much larger form. Speigelman's *Maus* started with a small story called "Prisoner of Hell Planet," which looks entirely different from the work in *Maus*.

Carol Tyler's *You'll Never Know* features a retelling of "The Hannah Story," which is about a sister she never knew and her mother's decades-old grief about it.

Never worry about having to redo a section. Many projects need their beginnings tweaked ("There's nothing worse than a good beginning"—Pablo Picasso), or a small nugget may suggest a larger context later, one which the nugget may need to be redrawn into. This isn't unfortunate, this is the creative process.

Write out a title and give yourself a limit: three, four pages, etc., and start.

LIVE EXAMPLE

DIARY COMIC

For my forest-themed story, I made this simple if sloppy comic, putting myself back in that world.

This time, I'm in the bushes being taunted to light matches and watch them go out in the midst of all that kindling. I'm not happy.

The realization in the last panel—"People can make me do anything"—is a strong one I'd like to explore later.

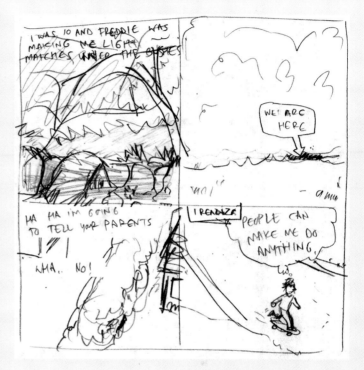

Playful cover ideas for a book I haven't really conceived yet.

COVERS

I did two covers for fun, that let me explore different kinds of imagery. One playfully had the Pink Floyd pigs floating high among the trees. In another, I just let the face and the slightly tired stance of the hiker be the subject.

SCRIPT

I thought I would write some thoughts as if they were captions. A script of sorts. I decided to focus on my driving through forests to meet my high school friend, Kathryn.

Forest memoir: SECOND ATTEMPT September 14

- Trees.

- I walk into these woods, past the red diamond sign.

- Two things I did in forests. One was BEING in them. I mean in the "be-ing" sense of the word.

- If our existence in the present moment exists as trillions of microbes and cells and other kinds of units and particles in states of being, then I was capable of being one of those units more often in a forest than any other place. . . .

- This is hard to describe.

- Trees always speak to a part of my mind, my movement.

- Small movement could speak to a part of my mind that nothing else could.

- It was hard to explain and hard to put into words, so I went away from it, and began to enjoy people, and cafes, and culture.

- The other thing I had done in forests was drive through them, on my way to people and culture and cafes.

- Following the power lines to my friend Kathryn, who lived in Woodstock, just off Route 28, where Sawkill Road turns into Zena Road.

- And I would drive to her through the woods, listening to Pink Floyd, so we could talk together about books, and music about being.

- They redid a whole psalm, she says. I hear song, I nod. Pink Floyd. In that song, "Sheep," they redo the Lord's Prayer.

- Oh.

- I never knew this. I really don't even know what a psalm is.

PART II

GOING DEEPER

In Part II, we'll look at deepening everything. From storytelling concepts to visual concepts to even the material itself.

"Visual concepts," for instance, means more than "how do we draw it?" It can mean the right tone or the right visual metaphor for the right moment.

And from organizing the material we move on to strategies of presenting it.

Then we'll look at adding complexity to our material by applying our current preoccupations and interests to the past experience that we're trying to convey.

And finally we'll look at bringing our current energies to merge past with present to finish the piece.

CHAPTER 6
STORYTELLING STRATEGIES

Storytellers have forever relied on narrative strategies to reach their readers. Some stories are bookended by a different story, some are stories within stories, some are "just so" stories, stories that start with an artifact or present-day condition, the story being a slow march to its emergence.

Every storyteller makes her own choices about how to tell the story. Stories can be told forward, backward, jumping back and forth in time. Even the simple word "meanwhile" suggests a conscious choice by a storyteller to avoid certain sections of a narrative in lieu of new ones, in the service of a greater thematic or dramatic impact.

Comics can learn from the long history of literature and narrative poetry, from the theater and cinema and any art form with a timeline.

In these three examples, which are all stories about parents, we'll see three different approaches to narrative, varying from tone to chronology.

TO THE HEART OF THE STORM by Will Eisner

Will Eisner began *To the Heart of the Storm* (1991, Kitchen Sink Press) "with the intention of writing a graphic novel about what I believed to be the 'biology of prejudice'" but in the end told a family history, a history full of scarcity, racism, and trauma, showing us how the past shapes the present.

SWIRLING AROUND THE STORY

The book happens mostly in flashbacks as young Will is being shipped off to World War II. Eisner looks backward and shows us his childhood and adolescence but also the history of his parents long before they even knew each other.

Eisner shows the reader his parents' story on the same pages that he shows us his own childhood stories, in particular his building of a boat with Buck, a German teenager as the Old World plunges into war.

Flashback after flashback compounds as older Eisner travels to duty. Eisner's flashbacks give us treatments of his parents' story separately, letting us see each character's difficult journey.

Will by Will

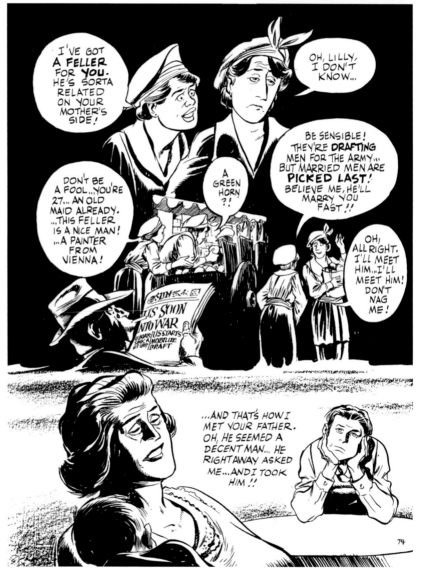

We see that his mother's and father's unique motivations for getting married were not exactly in concert. We don't even know how aware they are of each other's story.

Eisner allows a lighthearted subplot, as the German and Jewish teenagers' boat-building becomes a farce when they can't get it out of the basement.

THE STORM INTENSIFIES

In a time of panic and war, Eisner's parents found each other right for marriage mainly as resources to manage the scarcities around them,.

But around them, the dark storm of World War II is cohering. From the mouths of his German friends and neighbors come racist and prejudiced language. Soon, bigotry is everywhere, with all the prejudices of Europe coming to the fore, with everyone offering tribal opinions of the other: whites, Catholics, Germans, Jews, sophisticated Jews, peasant Jews, and the list goes on.

Time moves forward a few years and young adult Will runs into Buck, his early teen friend, who is now full of anti-Semitism. Meanwhile Eisner's publishing colleagues are full of racism and ethnic/religous tribalism, and finally Eisner, upon receiving a draft notice, rather than get "deferred on some angle," chooses to go to war.

Eisner the author pushes the book into the modern era on the train to camp, where we see more bigotry as enlistees comment on the African-American troops.

The book stunningly ends with Eisner meeting an American Turk on the train who converted to Christianity when arriving in the States. "I felt ashamed of bowing to bigotry." he says, but then, "Who I think I am is held together by optimism and bits of recall from my past."

The characters line up for duty and the Turk claims Eisner reminds him of "mythical Hoja . . . a wise man who always rides his donkey while sitting backward, to see where he's been. . . . After all, where he's going is in Allah's hands. . . ."

FUN HOME
by Alison Bechdel

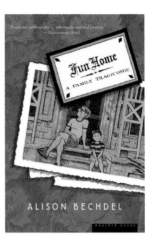

Alison Bechdel's *Fun Home* (2007, Mariner Books) is all reflection and commentary. It tells the story of her growing up with her father, an obsessive, closeted gay man who is also the town funeral director and who—when Alison is in college—perhaps or perhaps not commits suicide.

EVENTS REPEATED AND REEXAMINED

The book is a thematic exploration of her relationship with her father, and and she examines this relationship through various intellectual and psychological contexts: through the myth of Daedalus and Icarus, the myth of Odysseus en route to Ithaca, and stories of and by Proust, Wilde, Joyce, and Fitzgerald. She also re-examines events within their larger historical context as well.

The book's events are in no way presented chronologically. Events repeat consistently, sometimes as a re-examination, other times with great expertise in revealing key information for the reader.

The moment of her father's death is drawn at least four times, each with different illumination on the passages of thought she's patrolling.

Sometimes, through mere repetition she compounds the importance of depth of certain moments.

The image of Alison on the phone (left) with her mom as Alison learns about her dad's indiscretions is repeated. In the first time we see it, she says though she's escaped her parents and is in college, she's being "pulled back into their orbit." By the third time we see it, when we realize we're learning specifically about her dad's relationship with their babysitter, it's like she's space junk, floating and incapable of any of her own propulsion.

The book is essentially a series of essays. Events move through the book as if thought is more powerful than time. It's a feat of storytelling, using the intellect to negotiate history, repressed emotions, and misunderstood events.

Alison by Alison

THIS ABRUPT AND WHOLESALE REVISION OF MY HISTORY--A HISTORY WHICH, I MIGHT ADD, HAD ALREADY BEEN REVISED ONCE IN THE PRECEDING MONTHS--LEFT ME STUPEFIED.

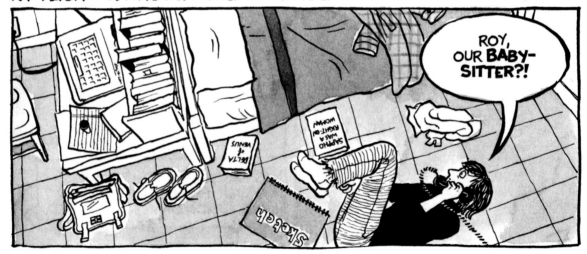

We've seen this image before, but with new information, we see Alison is now adrift, like space junk.

CAN'T WE TALK ABOUT SOMETHING MORE PLEASANT? by Roz Chast

SMALL SEGMENTS AND QUICK WIT

Roz Chast's *Can't We Talk About Something More Pleasant?* (2014, Bloombury USA), another book about parents, is essentially chronological—it follows the decline of Chast's 90-year-old parents to their deaths a couple years apart.

Roz by Roz

The Chast family doesn't necessarily talk about things.

And, more important, he was kind and sensitive. He knew that my mother had a terrible temper, and that she could be overpowering. She had a thick skin. He, like me, did not. She often accused my father of "walking around with his feelers out."

As the story progresses, Chast tells each segment of the story in whatever way serves the segment best. On the previous page, she's using a simple one-page humorous structure like you might see in her *New Yorker* cartoons. Another time she draws a board game of fear and doom. Another time, it's mostly text with a simple punctuating illustration. Elsewhere, it's all text. Here it's photographs. Finally it's tender drawings done at her mother's bedside.

This array of styles helps create its own arc. From humorous, irreverent, and even mocking, to more objective assessments, and then finally to just the intimate observation of a loved one's death.

Random shelf. My old baby shoes.

View of the Crazy Closet!

An array of styles depicts the story, increasing the intimacy in the book and creating a sort of formal arc, from distance to closeness.

AN ARRAY OF OPTIONS

Each of these examples raises various storytelling questions: Do we tell the story chronologically, or framed and within flashbacks? Do we instead tell it as reflections, letting the events return to us as the thoughts need them to? Do we tell them un-commented upon but stylized like Eisner, or as the subject of cool observation like Bechdel's book, or do we portray the story in a variety of forms, choosing a different method for each small section of the story, like Chast does?

Again, the answer is that we should follow our own organic intuition, but arm it with an array of options. That's what we're trying to do here.

I used a nine-panel grid as a basic page structure that I thought would remain underneath throughout the whole book. I didn't want to think too hard about page structure and I thought that if I got this one decision largely out of the way, my mind could be put to better use on the rest of the storytelling.

I also knew that the tragedy had to be part of the opening of the book, so that the rest of the book could exist as a sort of healing from it. So the book starts with a sort of overture, presenting the tragedy as the present, and then dials back to two years past and works chronologically using the nine-panel grid until we come back to that present.

It was at that point, seventy-five pages in or so, that I grew bored and frustrated with the nine-panel grid. And it also almost coincidentally was the right time to make a dramatic change in storytelling. So the immediate aftermath of the tragedy is drawn on black pages as if viewed through little tunnels. The chapter after that retains the black backgrounds as the page structure returns to an even simpler grid of six panels.

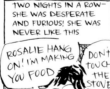

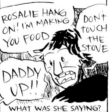

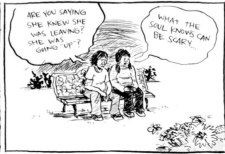

The grid is loose from here on in, though mostly sticking to the panel grid as our strength as characters return, but in at least two passages, the nine-panel grid is enforced when it's very much about Rosalie. All of this gives the book gentle, meaningful variations of rhythm.

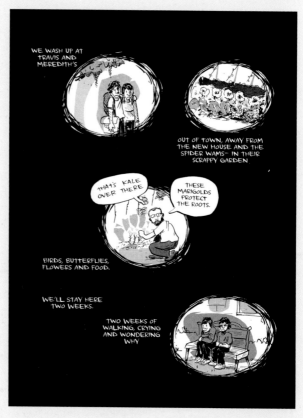

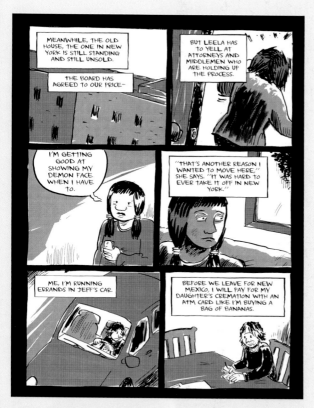

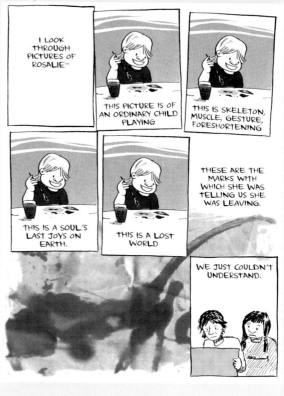

Storytelling Strategies: My Story

ESSAYS AND TRAINS OF THOUGHT

I was very inspired by the caption-heavy essays of Alison Bechdel, and I tried to let my mind follow thoughts as she does in her books.

Early on in the note-taking process, I kept track of my thoughts and made a list of "essays"—ideas about the experience that my mind was running toward to help me process the whole event.

Right away on page one, I began referring to other media—comics, movies, songs, stories, and art, etc.—and so it seemed natural to continue using such reference points throughout the book.

OTHER MEDIA AS STRUCTURE

Sometimes I was referencing the story that the characters go through, or powerful lines in songs, but other times I was just as interested in the formal structure of the other media.

The book *Louis*, a children's book by the cartooning team Metaphrog, for instance, appears at least four times, as a sort of supporting strut for my own book. Louis's journey becomes a model for my own, and the use of it in my book increases in complexity as it goes.

The first time I refer to Louis, for instance, it refers to Rosalie's imagination, the second, to the way in which I read it to her. The third time I use its imagery to visualize our own story, and the fourth time, I refer to its closing to find a way to finalize my own book's form.

These references go from Rosalie to a larger abstraction, which echoes the major arc of the book, carving a path through our own story.

META-STRATEGIES

Another sort of storytelling method that I used was to annouce the main crisis in the book—the sudden death of my daughter—early on, and address the learning that had to be gone through. From there, I told the story chronologically but so that this earlier material was always in the reader's mind.

More specifically, I showed us wrestling with the concept of will on the part of Rosalie. Did she mean to leave us? Was she trying to tell us? So that the readers always know that whatever they are reading should be addressed with these questions in mind.

The questions reappear at the end of the book as we come closer to answering them.

And I indulged in a final meta-storytelling scheme by treating the book as a book. I even announced the final scene ahead of time.

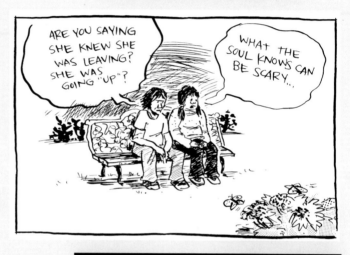

DO THIS

As you experiment with visual style, experiment with some storytelling styles.

FRAMING DEVICE

Like Will Eisner, consider a framing sequence: Who or what is larger or later than the story that's being told? Can we start and end there? It might be a character in the present, older now and reflecting, or a character in the book who comes upon the story somehow: finding it in a book, or a news item, perhaps. Or maybe it's a strange storyteller, in the book, but not in the story.

Who would be narrating your story and how would you depict them before and after the story?

Another option is an intense or vivid point in the story, perhaps a moment of tension. Start there, and then backtrack in order to get the story back to that point.

Or: a story within a story. Maybe people are trading stories, or maybe stories keep coming out of the current one, going further into the past?

FOCUSING EVENT

Like Alison Bechdel, find the most intense event in your story and examine it from different angles. What did it mean viewed in this light or that light? When you think of it from another character's point of view, how does it change?

When viewed isolated and utterly as part of a larger series of events, how different are the interpretations? Plan on depicting all of these viewpoints.

Is repetition a form of change? When you merely repeat the event again and again, what effect does it have on the story?

GO FURTHER

DIFFERENT APPROACHES

Like Roz Chast, try your story in a few different styles, like short strips, photographs with captions, and longer essays punctuated only by a few drawings.

Try a few more. Can you do a wordless section? A section read as if were being reported in a newspaper or on TV? What about a series of blog entries or diary entries? Text messages?

LITERARY COMPARE AND CONTRAST

Again like Bechdel, try finding a literary, historic, or mythic antecedent to your main character. Compare and contrast frequently. How is your character like Odysseus, or Hamlet, or Virginia Woolf? Find a grounding character and wrap your own persona or character around it like a maypole.

TO CAPTION OR NOT TO CAPTION?

Looking briefly over our array of twenty-four master examples, most use narration or captions extensively. Some don't use them at all. A lack of captions tends to put people in the moment, as if they are watching the story happen through a magic glass. The use of captions, or more specifically, a narrator, allows us to be moved through the story via a voice and personality, like a tour.

Try it both ways. Pick a section to render without captions. Pick one to render with. See how they work in sequence. Or try the same section using both ways and see how each way works.

DRAMATIS PERSONAE

List the cast of characters like a dramatis personae and don't deviate.

Why? We do this to sense the characters in the story. To distance ourselves from their real selves, to let them be characters on the page, in the drama. Let everyone have a role, at least for this exercise. You can add additional dimension back in where needed.

LIVE EXAMPLE

FRAMING SEQUENCE

I could simply frame the story inside a simple story of me looking up a tree I'd like to climb, feeling reticent, even frightened. The story would then be a reflection upon the beginning of an act. After the reflection is finished, I climb the tree. It's a little too simplistic, and I think I won't ultimately use it, but it certainly serves the assignment.

FOCUSING EVENT

I like this idea more. I think one of the events would be the act of photographing, either the chair in the woods, or the upturned roots mentioned in one of my lists. I don't know how deep or interesting that will get yet, but doing more writing and reflecting on it might help. Since I'm interested in seeing and art-making, I think this feels like a right direction to go.

DIFFERENT STORYTELLING STYLES

I love this idea too, and have been meaning to try it. But I think I don't have enough material yet. My idea right now seems smaller, not large enough to handle too many different styles.

LITERARY COMPARE AND CONTRAST

It sounds random, and frankly it is, but I've had this list of notes about artist Franz Kline on my wall for years. I dreamt about him one morning and woke wanting to do a story about him. His giant, brushy lines could be compared to trees, I suppose, though in reality he was often painting the opposite: trains and other giant industrial forces.

CHAPTER 7
VISUAL LANGUAGE

Comics is a visual medium. It's meant to be seen, and as such, we should learn as much as we can about how pictures work, and how pictures and words combine.

We have a history of image-making, from cave paintings to Rembrandt and Grandma Moses to emojis, to draw from. Let's draw from that deep well of human image-making as well as the history of the visual language of comics.

So let's look more at the visuals, and how we can start using the expressive potential of drawings and comics. We'll look at some examples—visual metaphors and similes, expressive drawing, and text/image combinations—that make comics really unique.

SOLDIER'S HEART
by Carol Tyler

Carol Tyler spent decades making some of the most interesting post-underground comics of the 1980s and '90s and started her masterpiece, first entitled *You'll Never Know,* in the early 2000s. It was collected as the award-winning *Soldier's Heart: The Campaign to Understand My WWII Veteran Father: A Daughter's Memoir* (2015, Fantagraphics Books).

Soldier's Heart looks at first glance to be a story about her father, a World War II veteran, but in fact takes at least three generations of Tylers—and Greens—as its subject matter. By linking the man with the war, and the man with the sons and daughters and then the granddaughter and son-in-law and even a lost potential lover of the author, we experience reverberations and echoes and tangles of frustration and pain and heartache that go beyond a simple biography or autobiography.

Tyler is a master technician who speaks the language of comics on every page she draws. In *Soldier's Heart*, a massive story spanning over 360 pages, she needed to keep the reader understanding who and when she was reading about, and engaged.

PANEL STYLES

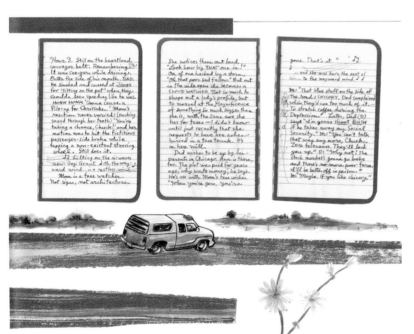

"Stuff in the army has its own style. Curvy-edged panels denote the past. Square panels are the efficient now.

"Anything with me and my husband and our kid in crisis mode is outlined in red and drawn in black and white, so it's very stark, and very immediate."

There's a lot of driving in Carol's story, and in this book. Some panels are landscapes that span across both pages and reflect the long journeys by the characters.

VISUAL TEXT

In a early page of the book, she introduces the book's main theme visually in the car-strewn landscape. As we move along from bottom left to upper right with her father Chuck's car, we can read embedded in the landscape: "Not All Scars Are Visible."

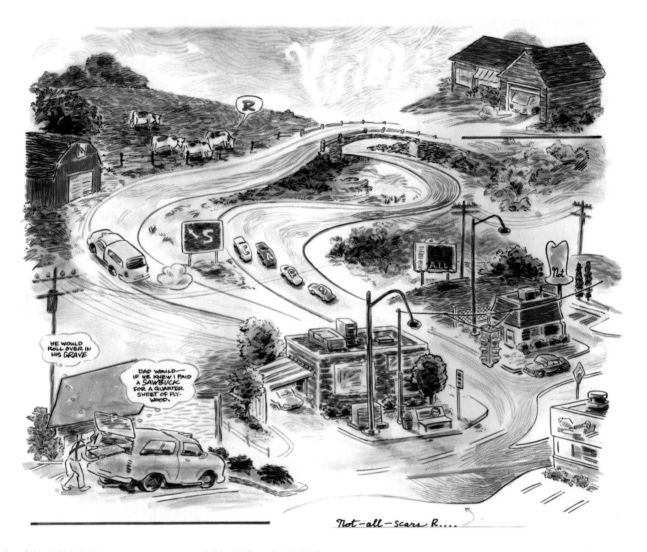

Soldier's Heart's fantastic opening main motif, "Not All Scars Are Visible."

RED RIBBONS

This page: some of the many instances of Tyler's "red ribbons."

Red ribbons weave through the book, with German text here, signifying rivers of blood here, paths between parents and children here, enclosing scenes and characters, being used as panel borders, and also manifesting as Chuck's suspenders, which are echoed as crisscrossing flowers on the back of Carol's jacket, subtly reminding you that the generations are constantly connected in this story of wounds and trauma.

Soldier's Heart does so many smart and powerful visual things that it's impossible to catalogue them all, but they add to the complete personal, intimate quality of this book about that most global experience—World War II.

Carol by Carol

EPILEPTIC
by David B.

David B. has crafted a graphically complex, challenging, and visually sophisticated style. His book *Epileptic* (2006, Pantheon Graphic), about growing up with his severely epileptic brother, is rich with visual allusions to history and myth.

The drawings in *Epileptic* are bold and striking and heavy with symbolism and every line is perfect.

In her mind, this sends us all the way back to square one. She has a vision of her son back in the hospital, his head shaved. It's as if she's being pulled backwards. She reminds herself that Master N. is no longer there.

VISUAL SYMBOLISM

David B. (real name: Pierre-François Beauchard) is someone for whom imagination and reality are closely linked. As a child, he imagines typhoons are coming to get him at night, and believes his brother's seizures are also typhoons.

"I really wanted to work out the drawings. How can I draw an epileptic attack, for example. Is it possible to draw that with a pencil and a piece of paper?" he said in a 2005 interview with *Time* magazine.

Pierre-François by David

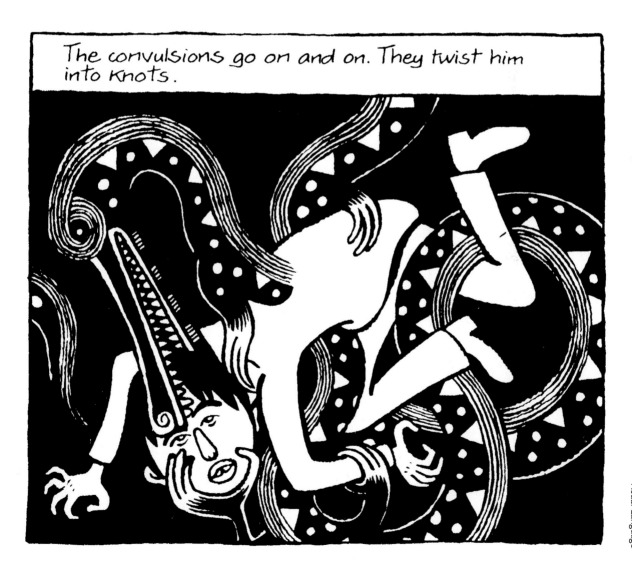

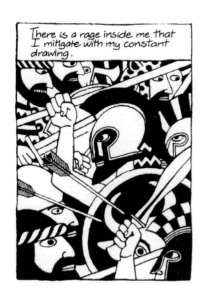

DRAWING THE INTERNAL WORLD

Like Raina Telgemeier's style, B.'s visual style is meticulous and consistent, in part because he is trying to render a cosmology. I think visual storytelling for him is a bridge between the conscious and unconscious, and I imagine that mastering the craft of it gets him closer to that other side and lets him experience it more fully.

The drawing below shows just one cosmology in his book, which is filled also with private myths and subconscious symbols, all meticulously rendered.

The experience of penetrating and traversing that internal landscape is one he shares with his readers through his drawings and storytelling.

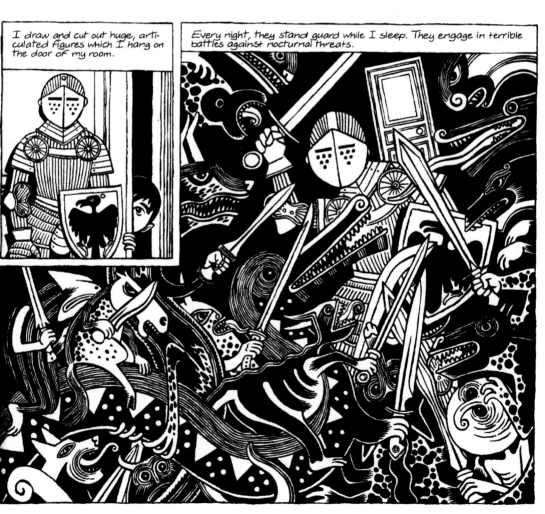

Epileptic moves forward as his family searches for decades for a solution to his brother's disease.

He and his brother are fascinated as children by war, and spend hundreds of hours drawing warfare together. They are each at constant battle with inner demons.

David's imagination expands as he reads occult magazines and he begins to believe in ghosts, devils, and other spirits. The child who was drawing silly battle scenes becomes the artist who chooses to depict his brother's epilepsy as mythic—an enormous, patterned dragon that the family is constantly battling against. This dragon image pops up again and again as the main antagonist in the book.

As his brother's external needs dominate the house, David retreats more and more into his dreams and imagination. We see the family story unfold as David's connection to his subconscious, Jungian world deepens. Soon, entire pages are drawn with nonliteral imagery. Doctors are cats, a dead grandfather is a giant-beaked bird, and the dragon of the disease grows increasingly larger and coils around itself over and over again.

Epileptic is masterful because it examines deeply the connection between the artist's drive to depict the inner world and the events of his childhood that created it.

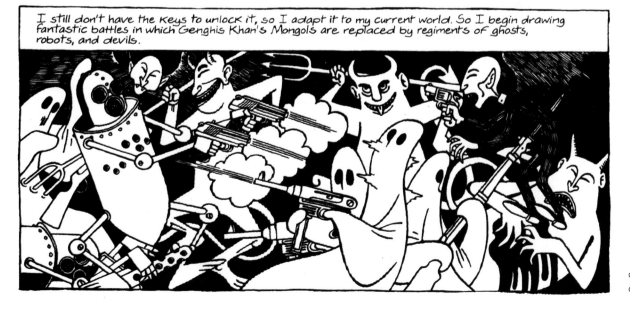

ARCHETYPES AND INNER WORLDS

The drawings in *Epileptic* are such powerful renditions of an internal world, it's no surprise they mimic the illustrations Carl Jung made when mapping out his vision of the unconscious. These samples from Jung's *The Red Book* coupled with drawings from *Epileptic* show imagery and internal myth working its way through generations.

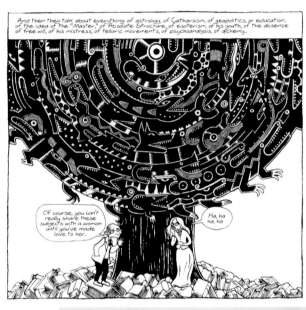

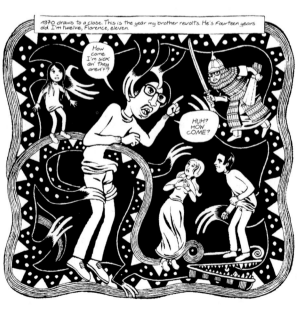

MONSTERS
by Ken Dahl

Monsters (2009, Secret Acres) by Ken Dahl is all about his diagnosis with herpes. And he goes in for depicting the virus in as much gross and funny detail as possible. He wildly showcases the physiological details but he also finds amazing, graphic ways to depict humiliation, shame, and self-loathing.

EXAGGERATION AND GROTESQUERIE

There are many great visual solutions in this book. The herpes virus appears everywhere, streaming up from under the ground and later as the sun in the sky before it becomes a wrapper around his whole existence for a year.

The virus becomes a constant companion he lives with and sleeps with in hilarious sections that feel like a bad roommate story.

Ken by Ken

And when he decides to learn more about it he shows himself literally diving deep into the disease to begin an instructive tour-de-force.

Monsters is a wild book. You have to revel in drawing, and a sort of *Mad*-magazine-like grossness to draw like Dahl. His love for drawing and his personal, visceral subject matter are a perfect match.

MY STORY

I tried everything I was capable of with this story and plenty I wasn't.

RATS AND RIVERS

Simple things like finding the right metaphor for certain ideas. The financial realities of New York City and New York itself became an enormous rat sitting in the water, which dovetailed with images in my own imagination of my wife and I traveling by life raft down a river.

That rat resurfaces a couple more times. And boats kept reappearing in my line of vision in reality, so they turned up in the book, too. So much so that sometimes, I'm not even sure what a particular metaphor meant—as in this example below of ancient Polynesian explorers making their way to Hawaii. When I drew it, I knew only that it was more alive than a simple illustration of the text.

Now in retrospect, I see that it implies a certain trauma, or at least a passionate drive to get somewhere, as it parallels other boat imagery in my book.

This image of Polynesians in a shoe-boat was a metaphor before I even understood it.

RIVER AS JOURNEY

The rat turned up three times, and began engaging us as characters, pulling us back as we tried to get away.

Related to that was the image of us on the life raft. That image was always in each of the rat panels, but very often alone, too, as a metaphor for our travels: half escape, half journey to unknown future. It bookmarks chapter nine, below.

THE METAPHORICAL CRASHING INTO REALITY

In another example, I struggled with this very literal image of Leela and me appearing at the front door of our friends', Kate and Lisa. The initial drawing, which I never even finished, was uninspired and never worked in the story.

Eventually, I realized that I had to bridge two main narratives in the book—the real journey and the cartoon analog—and push them into the same frame. This new image, at right, is much more alive and integrated into the story.

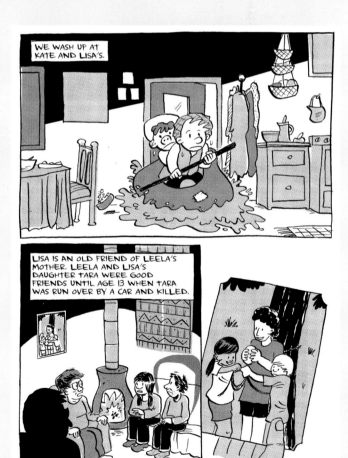

THE SQUAWKING IN OUR BRAINS

In a sequence that was mostly characters talking about real estate, I tried to at least make it lively by featuring the squawking of the pet bird our lawyer seemed to keep in his office. But it also served to illustrate the massive unreality of trying to deal with these administrative details during this time of horror.

At the bottom, I combined text from our lives and experience with images borrowed from one of Rosalie's favorite books.

In other places I tried contrasting small abstract self-representations with more realistic but expressive ones, trying to cover as much expressive ground as possible.

And sometimes I hoped the drawing itself would emulate the content, the scratching in this drawing reflecting the harsh frailness that I felt, for instance, in this snarl of traffic rendered as a tangle of lines.

ART AS METAPHOR

And because the book is about art and how it relates to the events, it became a journey through lots of different image-makers' work: EC Comics, Osamu Tezuka, Harold Gray, Renaissance painters, and more.

I borrowed lots more images and techniques as I went along.

Through Osamu Tezuka, I tried to show how our story, too, was about rebuilding our bodies.

PAGE LAYOUT AS METAPHOR

Here the form of the page becomes metaphorical, as I show my character having difficulty listening, not ready yet for that kind of interaction. The pages return to the simple six-panel grid immediately after this one.

In fact, I borrowed the top of this page layout from Kurt Wolfgang in order to make this dialogue-heavy sequence interesting, and only saw the metaphoric way in which it makes one speaker's words seem like a series of equally weighted, impossible-to-comprehend phrases.

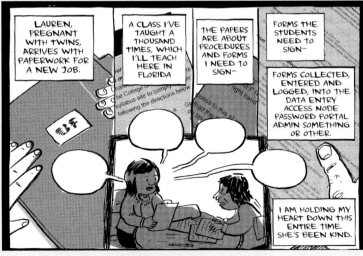

Another metaphor that found me, and is a form of the random image exercise, is one of the photographs in hands of lost children. As the book itself explains, this image was something that had been in my notebook for a number of weeks. When I rediscovered it after my daughter's death, it became a central image for the entire book. I used it over and over again, even tying into the nine-panel structure of the book, specifically as it related to the number of other stories of lost children that I found: eight, plus one in the center: Rosalie.

This page even seems a small manifestion of the web of life and death I was engaging with in writing this story. The book comes to a close after a ninth story of a lost child. A ninth card being pulled, the final in a deck.

THEN A PHOTOGRAPH OF A LOST BOY.

A DETECTIVE STORY? A LOST LOVER? A CHILDHOOD PHOTO? I HAVE NO IDEA WHAT THE KANJI AND KATAKANA SAYS

THEN I REALIZE:

WHY DID I ASSUME THIS BOY WAS LOST?

This random image from a manga hiding in my sketchbook became a central image and repeating motif for my entire book.

Above my drawing desk I kept a note during this project: It should *express* something, it has to *be* something, and it has to *mean* something.

Each drawing has to convey something, an action or subject. It has to add an emotional quality to that subject, but it also has to be a unique experience to itself. It was a hard prescription that I failed at fulfilling more than I succeeded, but the ideal kept me going.

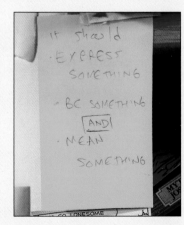

DO THIS

This is the section where we look for more powerful imagery. Visual metaphors and similes, ways of moving through the story visually.

We do this not to bore ourselves or the reader with our visuals, but, more important, to give our readers new passageways for the story to drive down. And also to find a way to make the process of writing and drawing compelling to us.

VISUAL SYMBOLS

Like Carol Tyler's red threads and ribbons, find a visual motif that can work its way throughout your book, tying it together and unifying the story. Let's note that a symbol need not be literal, and need not refer to anything outside of the story itself. Tyler's threads and ribbons are motifs that exist in the story and keep the story consistent. Ribbon, tires, eyes, rabbits, anything works. As these images reappear, our engagement in the story deepens.

VISUALIZE AN ABSTRACT ANTAGONIST

Here we can be more literal. David B. drew his brother's disease as a dragon in *Epileptic*, and Ken Dahl let his herpes become a vile little roommate. I drew New York City like a giant rat.

Find a substantial abstract antagonist in your story and depict it in a concrete visual way. Find an abstract antagonist—not a man, woman, or animal, but a disease, a misconception, a power dynamic. Find a way to depict that force.

Sometimes the best way to do this is to not worry too much about it. Let an image come when you are vacuuming, or walking the dog, or eating lunch.

Use that image in key moments of your outline.

GO FURTHER

PICK A RANDOM IMAGE

Find a stash of random images, and pull one from it. Type "film still" into Pinterest or Tumblr, and take one of those random images, and graft it onto your story. Force yourself to use a non-intuitive image. Something strange or inappropriate. It will train you to find the most appropriate ones later. For intance, is there a card from a Mexican loteria game that can match with a moment in your story? A Tarot card? A thrift store painting?

MISALIGN TEXT AND IMAGES

Make sure to take the image/text combination off the usual track of caption/image, caption/image. Instead, tell a section of the story silently, then find another part of the story to tell only in words. Mash them together in the same section and see how it works.

USE THE WORDS VISUALLY

Find a phrase in your story that haunts or affects the characters. Depict it visually as Carol Tyler did with "Not All Scars Are Visible," or Ken Dahl did with his explanation of herpes. Find any chance to render an idea with typographic solutions rather than just pictures.

DRAW THE ENVIRONMENT

There's a lot of research and talk lately about the effect of place on our memory and emotions. Let's take this time to draw a single separate picture of an important environment in the story. Doing this will help you inhabit the world of the story more. It may spark additional ideas later, story and visual ideas both. It will serve your subconscious, acting as a grounding that will be a place you can return to in your story-mind later.

Make the drawing as detailed as possible. Try to get to know the nooks and crannies of this environment. Thoughts and feelings will arise: This is good for your story.

Take another section of your story and tell it by focusing on place, either by removing the characters, or by letting the eyes of the story move around their environment.

LIVE EXAMPLE

VISUAL SYMBOLS

In rereading my notes, and thinking of the story that's developing, I'm seeing two or maybe three concrete visual items that could be recurring motifs or symbols in my story.

The chair in the woods.
What does it represent. Is it about the man-made world encroaching the woods? Is it about decay? Are the woods winning?

Power lines
Another symbol of civilization vs. forest. I've only recently begun realizing how ubiquitous these lines are along the roads of wooded areas. They're fascinating, watching them zig-zag across the road like a second path. One beneath our tires, the other, above our heads. This symbol emerged from the script when I wrote: "Following the power lines to my friend, Kathryn, who lived in Woodstock, just off Route 28, where Sawkill Road turns into Zena Road."

Of course Pink Floyd's pigs could feature as a symbol, or cars in general, or certain kinds of trees. Also, the enormous power poles that run through landscapes, that connect one community to another....

ABSTRACT ANTAGONIST

In trying to visualize an abstract antagonist, I think I need to research what my antagonist is.

What am I fighting in trying to relocate Kathryn? I love her, yes, and I miss her, but it's more like I want to believe that my youth existed. Did these conversations even happen? My mind was so open as a teen, but the person I shared it with doesn't seem to exist. Is my youth decaying, like that chair? Am I just going to become part of the forest floor—logs and branches and fungus and mulch? Is my time reaching for the skies like the forest canopy over? Who was I?

And what is at this missed connection? I think of these huge telephone and electric wires moving across giant landscapes. Certainly these giant monsters should be able to help me find her?

I'm not going to sketch this now, but I think I will plan to use these thoughts in my story.

CHAPTER 8
CHANGE YOUR LIFE

In this section, we want to stay alert during the process of creation, so much so that the story and the self change each other beneath each other's attention.

Let's continue searching for the story, for more material, wrestling with the material in the present to shape the past.

We can do this by adding facets and valences—looking for other angles, other connections, deepening everything with richer material from more sources.

Having more material from which to edit down is a healthy state for a creator to be in. And better if that material is rich, vibrant, and unique.

So we'll look at making our work and our material multifaceted and complex, like people. We'll look at creating thoughts and explorations that have many opportunities for combination with our other thoughts and representations. In short, we'll try to make our material more alive.

If our memoir is a story of a time past, our present-tense experience of telling the story can bring insight and experience. The word reflection begins to take on a new meaning. It's looking backward, yes, but this looking reflects on our present selves and changes us. This is what we want from art: to be changed.

So in this section we'll look at work that through multiplicity of thought and attention changed their authors during the process of making the book.

WHY I KILLED PETER
by Alfred and Olivier Ka

Why I Killed Peter (2008, NBM), written by Olivier Ka and drawn by the comics artist Alfred, is a difficult and harrowing story of abuse and trying to reconcile the past with the present. The protagonist is young Olivier, who found himself abused by the priest, Peter, at a summer camp. Olivier's awareness builds as he grows older and is able to comprehend the situation with more clarity at each age. Each chapter begins with a drawing of Olivier at a particular age and a new reason why he had to symbolically "kill Peter."

THE PAST MEETS THE PRESENT

The bulk of the book is rich with clever and elegant drawings and symbolism. Bold and loose brush strokes create atmosphere, while the characters are rendered in consistent cartoon lines. Occasional scratch pen lines create a feeling of angst and trauma.

The book culminates as adult Ka and artist Alfred visit the scene of the transgressions, but the path toward atonement is presented in raw, inelegant digital photos. It scrapes away our appreciation of the artistry of the earlier story to see it for what it really is: real life, banal, ugly, hidden in plain sight.

This scene is too urgent and raw to render in drawings. The artists want you to see it for yourself.

This is a great example of a book that begins before the story is completely known. Ka began his book without knowing how this final scene, a confrontation with the place, and perhaps the person, would play out. Creating the book instigated the scene. It created a secondary rationale for the revisitation. The act of creating the book was an act of generating strength, courage, and motivation for the protagonist to close one of the stories in his life.

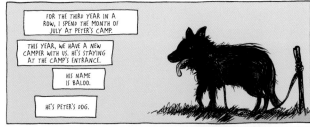

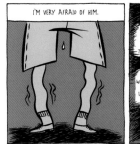

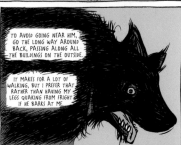

The book culminates in Ka showing the book-in-progress to Peter. The moments before and after this confrontation are a high-contrast collage of colored vague landscape photographs. The emotions here are rendered in abstractions that return to the concrete landscape, and then back to the characters. In the last two pages of the book, the lines are thin and sinewy, like a thread unraveling.

The book itself isn't just storytelling, it's an *experience* that the author needed to create to move the *story itself* forward.

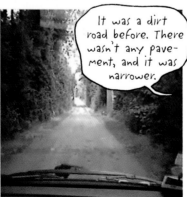

Olivier by Alfred

Images from the haunting ending of *Why I Killed Peter*.

I LEAVE PETER BEHIND ME, ALL ALONE AT HAPPY RIVER—

WITH THE BURDEN.

CALLING DR. LAURA
by Nicole J. Georges

Calling Dr. Laura (2013, Mariner Books) is a quirky and touching memoir by Nicole J. Georges about discovering that her real father is, to her surprise, still alive when she's been told for two decades that he was dead.

The story of this discovery is full of small twists and bigger turns, and Georges fills the book with so much personal story and detail about her love life and relationships with her pets and with the rest of her family that what comes out is a full story of a young woman growing into a mature adult.

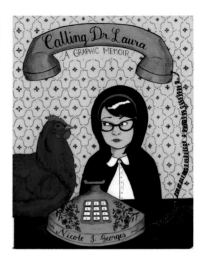

Nicole by Nicole

Georges says that she'd been telling this story orally to friends for years when finally she decided to tell it to the broader world as a graphic memoir. In doing so, she says, "the book took me somewhere I needed to go with my family . . . and it ushered in an era of honesty."

She continues, "The book helped me process things. It helped me piece together all of the random bits of information I had, and to verbalize the attitudes I held and how they got me to where I was with my family."

So how did she continue? How did she push forward to finish her story?

"I just kept going. I kept drawing, and I was sad and grief-stricken, and luckily that was all transmitted to the page in a way that affected readers as well and brought them there with me."

In the end, through all that, she created a touching book full of detail, fun storytelling ideas, humane interactions, and real heart.

ARE YOU MY MOTHER?

by Alison Bechdel

Alison Bechdel, in her second memoir, *Are You My Mother?* (2012, Houghton Mifflin), uses the art form to develop an external language intended to create an understanding of her fraught internal relationship with her mother.

Are You My Mother? is an exploration and, in part a destruction of this relationship. The psychology of the mother/child bond is the book's main theme and its events are almost entirely internal, as they relate to her relationships with her family, lovers, and therapists.

A VAST MENTAL LANDSCAPE

The plot of this book can be summed up as: Is she going to untie this Gordian/Freudian knot of her relationship with her mother? For a book with so many shots of the author in therapy or reading in bed, the story is utterly gripping.

Bechdel's quest for answers is a search for locations in an internal landscape laid out decades earlier. She searches for these answers in a few significant ways.

First, she starts off each of the seven chapters with an eventful and symbol-filled dream, which sets a tone and establishes a language of symbols for the chapter. The dream that begins chapter five, for instance, gives us images of Alison on a dangerous, isolated precipice of ice in the sea. She makes the harrowing climb to safety and sees that it was her childhood house all along. These images echo with the themes of working through her relationship with her father and his obsession with their family house, but also with her more dangerous dealings with her mother.

Bechdel also connects her own questions and explorations with two modernist thinkers, Virginia Woolf and the psychoanalyst Donald Winnicott. She sets up parallels between the two with a momentary flight of fancy, drawing them into the same London scene in 1924. From there, she constantly triangulates in on their ideas to locate herself in her own story.

As she tells her story, she explores it by looking for reflections of its dynamics everywhere, in other relationships, in her dreams, and in her actions with her lovers. And she sees her story in uncommon places, too: in the tightly wound wool of her teddy bear, in symbolic Dr. Seuss drawings, and in the themes and dialogue of a television show that played in her house, *The Forsythe Saga*.

Alison by Alison

Bechdel overlaps themes and dialogues from this show with her own family dialogues in a blistering, raw scene cushioned with indirection, as most things were in her childhood, within art and culture.

Bechdel wanders the external world as in a dream; her quest is so steeped in the psychological world that she sees symbols and meanings everywhere in everyday life.

She sees visual images as manifestations of her fraught internal dynamic. The casual naming of young Alison on this old photograph, for instance, seems like an arrow boring right into her head.

She is later accidentally hit in the eye with a twig while walking in the woods. She sees this as a self-punishment for looking too closely at her family, for staring at the unconscious too intently. It leads her to a meditation on a dream about a glistening spiderweb that opened the chapter.

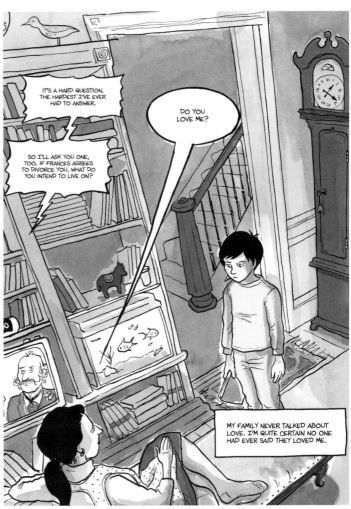

The TV dialogue sets up the tone of the real conversation in this panel.

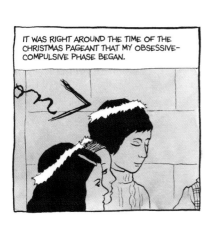

I COULDN'T FIGURE IT OUT. THE INJURY MADE ME TIRED. I LOST TWO DAYS OF WORK ON THE DAD BOOK, JUST WHEN I WAS BEGINNING THE PART ABOUT MY PARENTS' MARRIAGE.

IT ONLY OCCURS TO ME NOW, AS I'M WRITING THIS BOOK ABOUT MY MOTHER, THAT PERHAPS I HAD SCRATCHED MY CORNEA TO PUNISH MYSELF FOR "SEEING" THE TRUTH ABOUT MY FAMILY.

LIKE OEDIPUS GOUGING OUT HIS OWN EYES.

Bechdel's search for material to help her unlock her story is relentless; she is looking for new material even as she's working on the book. Even after the preliminary research and structuring of the book has begun, Bechdel shows herself on the phone with her mother, writing the book we are reading. She goads her mom, asking about sensitive topics that might open more meaningful apertures.

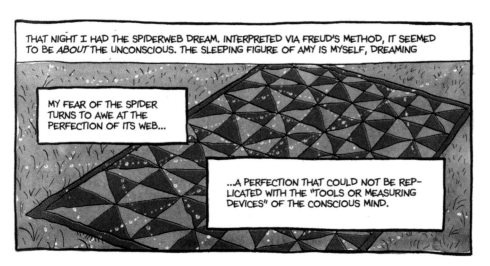

THAT NIGHT I HAD THE SPIDERWEB DREAM. INTERPRETED VIA FREUD'S METHOD, IT SEEMED TO BE *ABOUT* THE UNCONSCIOUS. THE SLEEPING FIGURE OF AMY IS MYSELF, DREAMING

MY FEAR OF THE SPIDER TURNS TO AWE AT THE PERFECTION OF ITS WEB...

...A PERFECTION THAT COULD NOT BE REPLICATED WITH THE "TOOLS OR MEASURING DEVICES" OF THE CONSCIOUS MIND.

Ultimately, although Bechdel's book is about the psychological concepts of compromise formations, reaction formations, and transition objects, she weaves in other personalities from the past and even the present, allowing her to create a web of thought and symbols and interpretations that enliven the whole project, the project of understanding her own being.

I HAD AN EXPERIENCE SIMILAR TO THIS MUCH MORE RECENTLY.

I JUST WATCHED THE MOVIE VERSION OF *A LITTLE NIGHT MUSIC*, WITH ELIZABETH TAYLOR AND HERMIONE GINGOLD!

REMEMBER THE SUMMER YOU PLAYED MADAME ARMFELDT?

I WAS HOPING FOR SOME GOOD MATERIAL.

I DON'T EVEN WANT TO THINK ABOUT IT.

IN ONE SCENE THE BUTLER LIFTS HER UP OUT OF HER WHEELCHAIR AND CARRIES HER...DID YOU GET CARRIED OFFSTAGE?

Alison in the present is digging for good material to add to her book.

MY STORY

NAVIGATING TO A NEW FUTURE

My book *Rosalie Lightning* was a quest to find meaning, or at least, as in *Why I Killed Peter*, an attempt to move beyond a certain point in my own story. A point of trauma and grief that I had to move through.

When I began, I wrote what I could about my present condition and my immediate past. I didn't know how the story would end. But I knew I had to get to a place where I could tolerate the new situation I was in. I had a mantra from a John Frusciante song that I would sing to the spirit of Rosalie when I was working: "There's only one way for things to be between you and me."

I knew that that "one way" was something she needed me to find. It was a new way that I wasn't used to; one of her choosing, one where she was no longer here, and I was no longer the authority.

Heavily influenced by Alison Bechdel, I looked for reflections of my own story everywhere. And like Bechdel, it wasn't hard to find symbols and images in history, art, and my own life that seemed to open a rift through which I could see more clearly.

Working on my book came in two parts: one of note-taking and trying to understand where I was, and then a period of drawing and integrating.

During the rawest, preliminary times, I tried to keep myself open to these images and symbols that presented themselves. I had to keep my eyes and my heart open.

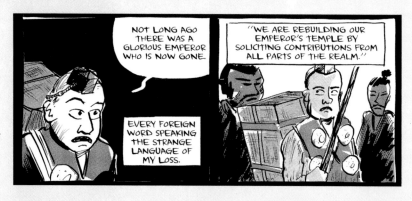

And so I saw my story in random places, the strangest perhaps being an Akira Kurosawa samurai movie. But in this odd story of moving from one land to another, hiding the personality under rags and pretending to be stoic, I saw my own story, and so I drew it into the larger fabric, that multivalent fabric of my story.

Similarly, a painting of St. Christopher and the baby Jesus by the Renaissance painter Titian seems to be about my situation: a baby whose presence is both heavy and light. How have these stories always existed? It seems they've been waiting all along for me to come to them in this state.

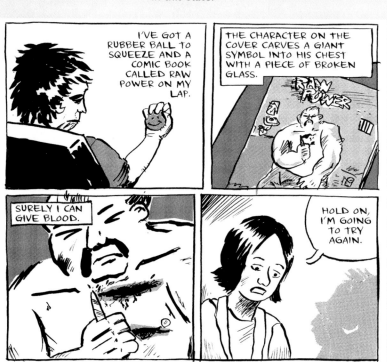

If you keep yourself open to symbology and messages from the universe, sometimes they come in highly coincidental, powerful ways.

For instance, when the book *Raw Power* arrived for me in the mail just as I had decided to give blood. The contrast was striking. The figure on the cover, strong, full of power, even bravado. Me weak, and incapable of much, not ready to take on the world. Just seeing your story in another image, even its opposite, can help that story deepen.

DO THIS

THE WHAT AND THE WHY

Outline who you need to be at the end of this book.

Ask yourself,

- What relationships need to change?
- What pressures need to be relieved, or what troubles need to be processed or better understood?

Our original question of "What story needs to be told?" could be amended to include, "What story needs to be experienced?"

Continue by completing these statements:

- I need to share this story because _____.
- When I finish this book I want to feel _____.
- When working on this book, I need to maintain the value of _____ above all else.
- I hope _____ will read this story and feel _____.

GO FURTHER

DAILY REFLECTION LOG

I don't have a good name for this, but let's call it a Daily Reflection Log. In it, I ask that you hold on to your story, think about your story throughout the day for a week, and look around you to try to interpret the things you see through the ideas and themes of your own story.

When you see something or engage with something, ask how it reflects on your story? How does it relate to your story?

Try for one a day. Make a list.

See my Live Example to see how that might work.

FOR FURTHER READING

Mary Karr's *The Art of the Memoir* is about the best book on memoir and life out there.

LIVE EXAMPLE

THE WHAT AND THE WHY

While writing this section, I became more convinced that this needs to be a story in which I find—or at least try my best to find—my best friend. If this leads me to a story about forests or something else about the passage of time, so be it. I'll work with what the story gives me.

When I decided to go this route, I had my rough script, which led me through the first three or four pages. After that, I knew I would be visiting my hometown and that I would at least make the drive I made weekly almost thirty years earlier.

And so, using the model of Oliver Ka's *Why I Killed Peter*, I'm going to leave the ending open. Finding her or not, that will close the story.

I also want to answer my own questions here.

What relationships need to change?
My relationship with forests, and my relationship with my friend. Maybe an internal one I have yet to see.

What pressures need to be relieved, or what troubles need to be processed or better understood?
I need to not feel abandoned by my friend, and thus not feel as if my youth didn't exist or didn't matter.

I need to share this story because I feel
like the theme of loss and reconnection is a powerful one that many people share and need to read stories about.

When I finish this book I want to feel
stronger, as if I've moved from not knowing to knowing.

When working on this book, I need to maintain the value of
openness to the truth about the present above all else.

I hope *general readers (maybe a cop-out!)* **will read this story and feel** *that their lives are full of quests.*

I am also sensing that the major themes are simple ones of loss, aging, and change, and I need to be open to places in the story where those themes become present.

LIVE EXAMPLE

DAILY REFLECTION LOG

In Go Further, I recommended keeping your story with you, and looking around you for ways in which your story can be reflected in your present life. I did it for seven days.

Day 1. I see a hawk sitting on the bank of the pond. Hawks don't do that! A second hawk comes up from the pond and sits with the other. They stay there.
Are these hawks Kathryn and me?

I bike in heavy traffic and I don't signal.
Have I become old and uncommunicative?

Day 2. I think of my friend Yaz's story of growing up black and afraid in the south. Always worried that she might create a Rosewood massacre.
Our fears are complicated and start early.

Day 3. Cleaning my art studio for a new beginning. First thing I find are rat turds and chewed-up acorns.
Everything decays.

Day 4. I see two men setting up chairs outside a house. In the direction of the house. They are sitting staring at it. On my way back, I see they have paint samples.
What can we change superficially? How much do we need to stare at it before making a decision?

Day 5. I finish a novel by Lauren Groff, *Fates and Furies*.
We never really know each other.

I read a story to my daughter. I wonder:
Do children think animals go to school?

Day 6. An Oliver Sachs article about Spaulding Gray's last suicidal months.
Our minds and connections are chemicals and bound to imbalance and deterioration.

Day 7. At an art show, a man with his enormous, scary propane torch going off at random intervals. Then learning he is a vet with PTSD.
Who knows what trouble is underneath our behaviors?

This exercise has given me insight into how I am currently seeing my story, revealing at least one theme I don't think I saw clearly: "unknowing."

And it has possibly given me new ways to tell it. I could weave any of these images in: the hawks, the men staring at the house, the man with the torch, the art studio.

CHAPTER 9

FINISHING

Finishing is harder than starting. Lots of projects get started. But I want you to *finish* your project, which means getting back to your chair or easel or whatever, day after day and telling your story.

If there's one thing I want to emphasize, it's that the making of the book, this memoir in whatever form, is an experience just as the story you are telling is. This experience needs to be something that you want or are prepared to go through.

The process can be as vivid and complete a journey as the ones our stories depict: full of ups and downs, twists and turns and unexpected events, and new insights and weird coincidences, and maybe profound revelations.

It may be hard to do this. If you're telling a difficult or tragic story, let the process of working on it be a healing process.

If your story is an ultimately positive story, then let your work be a celebration of it.

Let's look at three examples.

THE PHOTOGRAPHER

by Emmanuel Guibert, Didier Lefèvre, and Frédéric Lemercier

THE EXPERIENCE AND THE STORYTELLER

Didier by Emmanuel

There's a separation that sometimes has to happen to get that book done. You need to believe that this story is worth telling and then you need to "devote to it all the time and concentration it will require" as comics artist Emmanuel Guibert says about *The Photographer* (2009, First Second), a book born from this divide.

When Guibert saw his friend Didier Lefèvre's contact sheets of 4000 photographs from a trip to Afghanistan, he knew it had to be a book. He listened to Lefèvre recount an incredible story of hardship, war, medicine, art, and near-death travels with a caravan of Doctors Without Borders doctors and nurses deep in rural Afghanistan in 1986.

"I wanted . . . to put the reader in my situation," Guibert says of hearing his friend's story. Guibert's skill was drawing and storytelling, and so he tasked himself to share Lefèvre's story in the way he was best equipped. (Frédéric Lemercier designed the layout and colored the drawings.)

Guibert claims it is more "a testimony. . . a documentary than a narrative."

This testimony, which is in fact also a harrowing narrative, starts simply. On page 37 as they climb the rocky pass into Afghanistan, Guibert draws Lefèvre saying "I wonder what I'm doing here?"

And then, "I answer it by taking photos."

But by page 219, Lefèvre is abandoned, alone in dangerous terrain, trying to get home, frozen and broken on an immense rocky summit. In this crisis he writes through Guibert. "I take out one of my cameras. I choose a 20mm

lens, a very wide angle, and shoot from the ground. To let people know where I died."

And then page 224, "I rummage for my notebook, a pencil, and my forehead lamp. . . . I can't see how I'm going to make it out of here. . . . I hope that this notebook and my pictures will reach you."

Who is the rummager who is doing the writing? How has this notebook reached us? Who has had this near-death experience?

Guibert writes, "I had to reconstitute a diary, a day-by-day documentary of a story which had taken place eighteen years before. So, under Didier's control, I really tried to write as if I were in his shoes, living the adventure myself, but myself as Didier."

Guibert had to step in as translator, but also to relive the experience through his translation.

Together, they created a book full of complicated social detail, rich visuals, sad and terrifying sequences, ultimately creating a second powerful experience out of the raw material from the single harrowing trip.

The unique combination in this book of drawings and photography, and of experiencer and translator, combined to create a book unparalleled in its richness, grace, and depth.

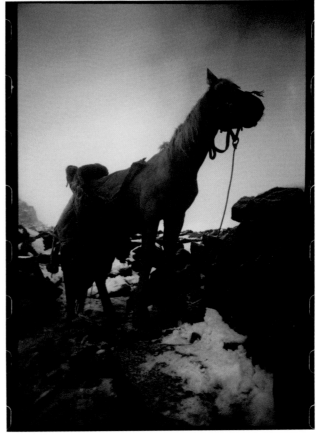

SOLDIER'S HEART
by Carol Tyler

AN ARMY OF MATERIAL, AN ARMY OF INKS

Carol Tyler's *Soldier's Heart* is such a arresting, complicated book, it's essential to look at it again here.

Tyler uses sophisticated art techniques to connect the dramatic events—the fighting, the courting, the house-building, the drug addictions, the hospital stays, etc.—with her own internal world.

The book is an artist's attempt to paint her way out of rage and regret and into something that looks like acceptance.

At the center of Tyler's father's story is his service in Italy in World War II. Over the course of 364 pages, she tackles the issue of her dad, his war trauma, and the effect on the family from every possible angle. "Once I found post-traumatic stress disorder as the central motif of the story, I found the organizing mechanism I needed to tell the story," she says.

"I amassed an army of written material," she says, in the form of reference books from the library.

But that's not all.

To tackle this subject, she wrote notes on adding machine tape, circling in red marker the items that mattered most.

"You start by taking notes and then connecting the ideas on strips of paper. . . . I had them taped all over the house. . . . I would literally write on the walls at times. . . ."

When Tyler took her stoic 1950s father to the World War II memorial, he broke down and cried.

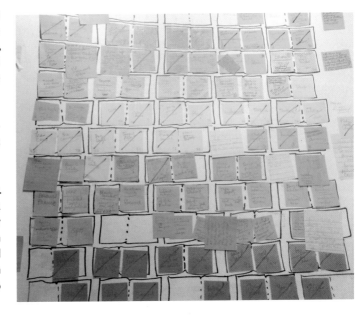

"I wrote the whole book to lead up to this climax," she says. "He would have to undergo a transformation, but to get the importance, readers would have to know us as people. . . . I had to bring the emotion that I felt and that he felt to that point."

Developing the stories of all the people involved through all the eras of their lives was the goal.

"I had three sections, and five characters. There's the story of dad as an old guy, as a married man, as a young man in the army, my story as a young girl dealing with him as an army guy, my story of dealing with them as old people, my story of being a married person, I'm also dealing with being a mother to a child who is troubled. . . ."

To organize it all, she resorted to charts and spreadsheets, even gridding out lines directly onto a tabletop and filling it with Post-it notes.

But she goes even further: "I actually had to build furniture to deal with it. I got out the saw like old Dad. I built shelves to manage the pages and a long tilt table so I could see the pages laid out in sequence."

It becomes clear at this point that Tyler isn't just trying to tell the story; she's trying

Tyler's ink army.

hard to climb out of it.

Tyler is a tireless artist and a master technician. She amassed another army. "An ink army. Fifty-three colors of custom-mixed ink. I had to make maps so I could keep track of them."

In *Soldier's Heart*, she tries an array of techniques—full-color paintings, pen and ink, simple cartoony lines, redrawn photographs, and on and on.

And Tyler involved her ill mother, suffering from a stroke, in the making of the book. "I sat her down, and had her do a page. I said, 'Do whatever you want.'"

Her mother painted five stars in bloom representing her children, one representing her firstborn daughter who died at two. That star is crying. Beneath the stars, she painted herself and Carol's father as hearts, and wrote WWII at the base. She titled it, "Out of war, came our children."

I can't think of another book that involves the participants in the story so fully and with such love and vulnerability.

Throughout this book, which took Tyler ten years, she experienced incredible loss and trauma, and sometimes wasn't sure how to keep going. She tells the story of traveling on a highway during the creation of it:

This emotional and symbolic page was painted by the artist's mother.

"On the way to Mom and Dad's once, this semi-truck in front of me suddenly flipped up into the air vertically and flew over the guardrail. Frightening! So I pulled over to see if I could help. Just then the driver miraculously emerged from his upside-down cab, unscratched.

"I thought, if he can survive that, I can survive this."

The book is a reflection on a life's past but is also powerfully the product of a life lived and rendered in the now.

MAUS and METAMAUS
by Art Spiegelman

PUTTING THE DEAD INTO LITTLE BOXES

One look at the notebooks and sketches for Art Spiegelman's Pulitzer Prize-winning *Maus,* as seen in the supplemental book *MetaMaus,* shows that it took a tremendous force to make the book.

"I didn't know if I'd come out on the other side of it," Spiegelman says in *MetaMaus.* "I knew I was taking on something enormously difficult. . . ."

He adds, "And from the get-go, I was trying to give shape to it without knowing what that final shape would be. . . .

"The subject of *Maus* isn't just the story of a son having problems with his father, and it's not just the story of what a father lived through. It's about choices being made, of finding what one can tell, and what one can reveal, and what one can reveal beyond what one knows one is revealing." He says you're "putting the dead into little boxes."

RISKING DISTORTION OF THE UNDERLYING REALITY

"There are so many choices, so many options and so many ways to assign perspective to the material." Spiegelman says, ". . . giving shape also involves, by definition, the risk of distorting the underlying reality.

"Perhaps the only honest way to present such material is to say: 'Here are all the documents I used, you go through them. And here's a twelve-foot shelf of works to give these documents context, and here's like thousands of hours of tape recording, and here's a bunch of photographs to look at. Now, go make yourself a *Maus!*'"

Art by Art

GO MAKE YOURSELF A MAUS.

The propulsion for Art Spiegelman to create *Maus* was in part "an impulse to look dead-on at the root causes of my own deepest fears and nightmares," and his life was never the same.

With *Calling Dr. Laura*, Nicole Georges ushered in a new relationship with her family.

Vanessa Davis says, "I feel a bit unsupervised in the world. Putting the comics out there helps me with that."

In *The Photographer*, Didier Lefèvre says, "I wonder what I'm doing here? I answer it by taking photos."

Oliver Ka faced down a demon in *Why I Killed Peter*.

And I traced the outlines forward in my own life and tried to follow them into the future.

Nicole Georges says something funny about her story:

"Internally, it isn't a part of me anymore. Is it gross to say it was like a placenta? Like, the book is a new organ I grew for a specific purpose, gave birth to, and now it belongs to everyone else. I can let the story go in some ways. I created a bridge between myself and the world where otherwise there was silence and isolation in dysfunctional secrecy."

Whatever metaphor you use, or whatever function it serves, experience that new growth. Nurture it and release it.

If there's one point to this section, it's that the act of making your book or project or story shouldn't merely be one of "telling a story." It should change you.

The telling of your story is a process. The best way to finish is to be engaged in that process.

The process should be a way of processing or internalizing, or completing or comprehending the experience you're talking about. Telling the experience should be an experience, too.

The process isn't merely artistic, it's transformative.

Finishing
MY STORY

For me, I took 3 years to process five weeks of experience.

EXPERIENCING, WRITING, INTERNALIZING

Every day I worked on the book, I was reliving an experience that was intense, but also sudden and shocking. I think I needed to re-experience it slowly or experience it from further away to really let it change me for the better.

Drawing certain events brought me back to them, and deepened them for me. Trying to manifest things I saw or felt with ink on paper was a separate battle for understanding and consolation.

Art is a safe area to take risks.

There were times that I couldn't draw what I believed to be the right image, and I either had to return to the battle another day, or give in and let the image be what came out. I had to create relationships with failed drawings just as I had to create a new relationship with my dead daughter. For me, this mimicking is healthy.

I know a lot of people who are perfectionists and would never settle on a drawing that didn't work like they wanted, but they are better artists than I am. I had to settle now and then, and say this is the experience, and this is the story of the experience, and neither is what I expected.

Such is life.

In the end, the thing that nags me the most is the stuff that didn't make it into the book. There was probably enough material for another two books, but this is the material that asserted itself. The other stuff is stored away and might come out in other stories—who knows?

I don't pretend to know the future anymore.

I restaged and documented nearly every physical experience, even simple ones like walking, so I could relive and internalize the experience.

I worked three years telling a story that took place mostly within five weeks. This was a slow, healing, processing experience. I think the messages that the world sent me it sent me quickly. But for me to understand them—to integrate those messages into my larger being—I had to work with them for those years.

I drew my little daughter alive and running around, curious and expressive. I drew my wife and me in shock. I drew us broken, confused, angry, and sad.

I AM WONDERING HOW THIS WILL END.

WITH ANOTHER CHILD?

WITH DEATH BY TATTOO NEEDLE?

BY BECOMING A GRIEF COUNSELER?

I drew us connected with other people. I drew us trying to process. I drew cartoon versions of us. I drew stand-ins for us. I drew abstractions of all of us. I drew symbols—acorns, boats, and trees. I drew other people's drawings. I illustrated songs.

Some of it was hard; most of it was a wrestling match. All of it was an endeavor to process my experience. To tell it and to crawl out of the experience anew.

KEEPING ON TRACK

A big project sometimes needs some project management. There are lots of apps and skills and managers able to help you with that.

For me I needed to keep logs just to keep seeing that I was making progress, because a lot of times it felt like I wasn't progressing at all. The logs helped verify what my anxiety and frustration was keeping me from seeing: that the process was moving forward.

1	DAte	day	movies, books,articles	movies, books,articles	ideas	worked on	m
282	10/7/2014	Tuesday				papillon	
283	10/8/2014	Wednesday				worked on papillon	
284	10/9/2014	Thursday				finished 3 papillon pages	
285	10/10/2014	Friday					
286	10/11/2014	Saturday					
287	10/12/2014	Sunday				revised three pages (little panels.) began resizing black pages	
288	10/13/2014	Monday				taught etc	
289	10/14/2014	Tuesday				added Verbeek sketches, 2 pages. finished writing varden scene	
290	10/15/2014	Wednesday				really fighting with this garden scene, sketched new page 208, scanned, bringing into scene. what to omit, what to keep? how to thread needle? began penciling bunny at beach scene	
291	10/16/2014	Thursday					

1	DAte	day			
29	1/27/2015	Tuesday	before kiss.		
30	1/28/2015	Wednesday	emailed with editors		
31	1/29/2015	Thursday			
32	1/30/2015	Friday			
33	1/31/2015	Saturday			
34	2/1/2015	Sunday			
35	2/2/2015	Monday	drew some of atm page		
36	2/3/2015	Tuesday	drew atm page		
37	2/4/2015	Wednesday	drew most of chap 9 kate lisa wood page		
38	2/5/2015	Thursday	finished chap 4 page 10, long awaited		
39	2/6/2015	Friday			

DO THIS

I encourage you to be in your story again. Use this as a chance to live twice. If the story you're working on is a positive one, then let the work be a celebration of it. If it's a tragic story, then let your work on it be a healing. What follows are other good self-assignments to keep yourself going.

START A LOG

In the middle of a big project, it may be hard to see you've made any progress at all. Start a private log. Each day, write down how you pushed the project further.

When you look back at that log, even if you've got big holes in it, you'll still see that you're moving forward. Continually moving forward is all it takes.

At the best of times, I kept a log. On a Google spreadsheet, I logged what part of what pages I did every day I worked. Looking at this, rather than the art and story itself, which was always loaded with emotion, helped me realize that I was, in fact, making progress.

If you are capable of sitting down and working one day, you're capable of doing it again. And if you're capable of getting down and working many days in a row, then you can finish your book. You may just need some reminders that you're making progress.

FIND SOME READERS

It's probably obvious, but there are tons of comics and comics sites on the web. Join them. Start a site for your project and invite others to look on. Finding friendly voices to egg you on, online, or in person, too, is sometimes essential.

I found it imperative toward the end to have a few readers with whom I shared early drafts. I might have been disingenuous when I asked for criticism—I probably really wanted affirmation. It's okay to ask for that, too.

Find readers online, in public, or privately, but allow yourself a cheering section. I now host a forum of readers and creators doing just this. I see it helping people every day.

GO FURTHER

START A DIARY

Each day, take five minutes to reflect on the process. Hard, easy, technical details, personal details, Morning Pages, whatever. Shedding this skin each day or each session will allow you to be stronger than the pain, the process, the difficulty.

WRITE YOURSELF SOME ENCOURAGEMENTS

There are times when it's hard to go on. I wrote, "Nothing matters but you have to tell this story" above my desk, but that didn't prevent life, distractions, and inertia from getting in the way. This note helped remind me to stay on task. Write whatever you need to be reminded of, tattoo it on your arm, or put it anywhere you will see it every day.

REDEFINE "FINISHING"

Be easy on yourself. It may be that we weren't meant to "finish" this project. Or else perhaps our "finishing" doesn't look like the ones in this book.

I am not sure if "finishing" holds an inherently better value than merely messing around.

Is a finished project necessarily any better than just staying in a therapeutic/manifesting mindset? If we're sketching, and writing and drawing and talking, do we need to be "finishing" something?

For some, it's certainly yes. Finishing brings some of us to a place of completion; it allows a stage to be passed through. It allows us to put something fully in the past, and to become someone who has gone through that something, rather than someone who is still wrestling with it.

But maybe our note-taking, our material gathering, or story structuring, our sketching, and our starting was all to bring us to a new form. Maybe that new form will be a quilt, or a sculpture, or a new job or a new role in a new community.

FINISHING

I am like an 85% finisher. I have finished a lot of projects, and I have also *not* finished plenty of them, too.

I think about the ones I've left unfinished. Should they have been finished? Was it okay that I abandoned them? Did those unfinished thoughts, feelings, and labor get incorporated into other work? Should I go back to those stories?

I don't know.

My book about my daughter wasn't easy to finish, but it was harder to not finish it. But this isn't always the case.

In some cases such as in this live example, inertia or other obstacles come in to keep us from moving forward.

Here, I felt thwarted by unexpected story turns. I thought I would find my friend, and never did, and this was disheartening. I had to find another reason to finish. Another goal.

Going back to the Change Your Life chapter, I asked myself:

What relationships need to change?
I need to be able to exist in the forest more. I need to see the trees and woods as my home.

What pressures need to be relieved, or what troubles need to be processed or better understood?
I need to find continuity between the teenage me, who listened to Pink Floyd and talked to his friend about books and life, with the adult me who runs a school and is obsessed with paying the bills.

What story needs to be experienced?
I need to walk back to having a relationship with the forest. I need the older me to know younger me.

With these in mind, I looked for material for this story and worked.

FOREST STORY

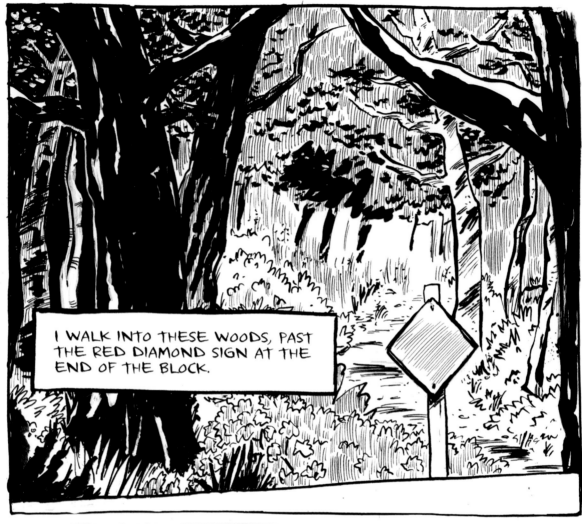

I WALK INTO THESE WOODS, PAST THE RED DIAMOND SIGN AT THE END OF THE BLOCK.

REMEMBERING TWO THINGS I WOULD DO IN FORESTS.

The Art of the Graphic Memoir

ONE, WAS BEING IN THEM. I MEAN IN THE "TO BE" SENSE.

IF OUR EXISTENCE IN THE PRESENT MOMENT IS AS TRILLIONS OF MICROBES AND CELLS AND OTHER KINDS OF UNITS AND PARTICLES AND STATES OF BEING—

THEN I WAS CAPABLE OF BEING ONE OF THOSE UNITS MORE OFTEN IN A FOREST THAN ANY OTHER PLACE.

THIS IS HARD TO DESCRIBE.

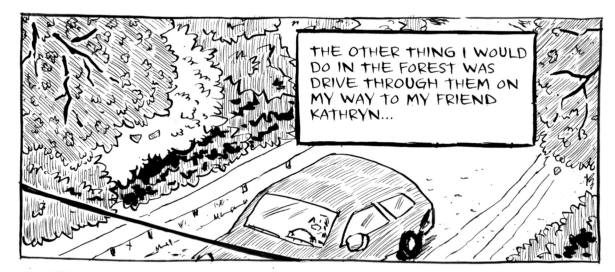

THE OTHER THING I WOULD DO IN THE FOREST WAS DRIVE THROUGH THEM ON MY WAY TO MY FRIEND KATHRYN...

FOLLOWING THE POWERLINES DOWN SAWKILL ROAD—

LISTENING TO PINK FLOYD'S ANIMALS—

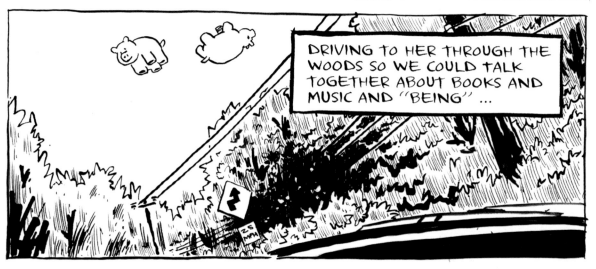

DRIVING TO HER THROUGH THE WOODS SO WE COULD TALK TOGETHER ABOUT BOOKS AND MUSIC AND "BEING" ...

THEY REDID A WHOLE PSALM.

IN THAT SONG, "SHEEP", THEY REDO THE LORD'S PRAYER.

OH

I NEVER KNEW THIS.

I DON'T EVEN KNOW WHAT A PSALM IS.

ON THE WAY HOME I LISTEN. IT'S LOW AND HARD TO HEAR, MAYBE ONLY IN ONE SPEAKER...

WHAT IS A PSALM? SOME SORT OF BIBLE THING?

HE MAKETH ME TO HANG ON HOOKS HE CONVERTETH ME TO LAMB CUTLETS

WHAT HAPPENS WHEN YOU DISTORT A HOLY THING AND MANGLE AND MAKE IT SOUND METALLIC AND SINISTER?

WHERE I GREW UP, THE TALLEST THINGS WERE TREES—

TREES, AND THESE THINGS.

POWER THINGS.

I'M JUST DELIRIOUS TO LOOK INTO HER EYES AND TALK.

CROATIAN, SHE SAYS OF HER FAMILY'S BACKGROUND.

HER EYES, CLOSE SET.

I'VE STARED DEEPER INTO THEM MORE THAN ANYONE'S EXCEPT MY WIFE'S.

HER SMILE EMERGES HALFWAY SOMETIMES.

I FEEL I HAVE TO CATCH IT ON A HOOK TO KEEP WITH ME.

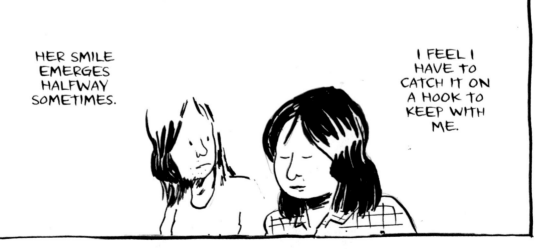

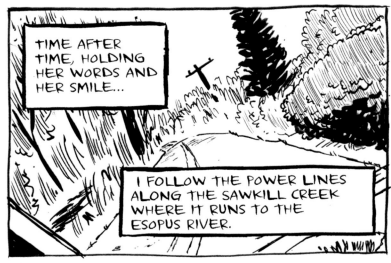

TIME AFTER TIME, HOLDING HER WORDS AND HER SMILE...

I FOLLOW THE POWER LINES ALONG THE SAWKILL CREEK WHERE IT RUNS TO THE ESOPUS RIVER.

WORDS ARE JUST LIQUID.

I JUST WANT TO BE FREE.

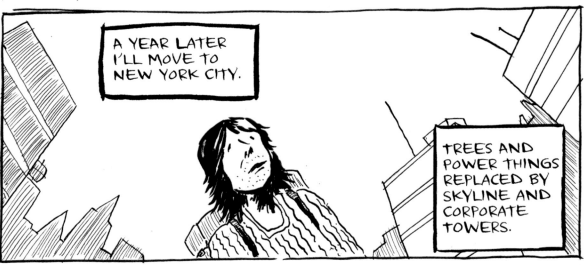

A YEAR LATER I'LL MOVE TO NEW YORK CITY.

TREES AND POWER THINGS REPLACED BY SKYLINE AND CORPORATE TOWERS.

AND SEATTLE 2 YEARS AFTER THAT.

KATHRYN IS IN ALBANY. BY THE TIME WE ALL HAVE EMAIL ADDRESSES, WE EXCHANGE MAYBE ONE EMAIL A YEAR.

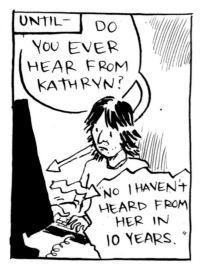

UNTIL— DO YOU EVER HEAR FROM KATHRYN?

"NO I HAVEN'T HEARD FROM HER IN 10 YEARS."

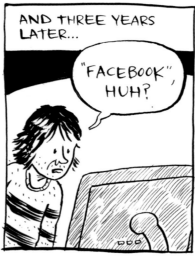

AND THREE YEARS LATER...

"FACEBOOK", HUH?

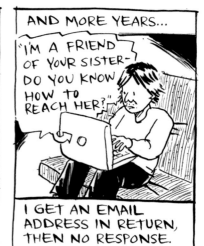

AND MORE YEARS...

"I'M A FRIEND OF YOUR SISTER— DO YOU KNOW HOW TO REACH HER?"

I GET AN EMAIL ADDRESS IN RETURN, THEN NO RESPONSE.

MY FAMILY AND I PACK UP AND MOVE TO CENTRAL FLORIDA.

SPANISH MOSS AND PALM FRONDS.

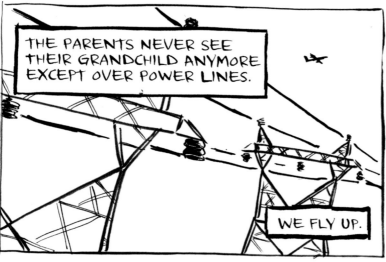

THE PARENTS NEVER SEE THEIR GRANDCHILD ANYMORE EXCEPT OVER POWER LINES.

WE FLY UP.

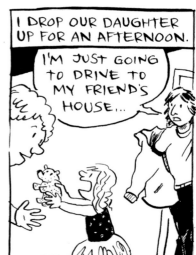

I DROP OUR DAUGHTER UP FOR AN AFTERNOON.

I'M JUST GOING TO DRIVE TO MY FRIEND'S HOUSE...

RT 209 IS THE SAME, I GET OFF AT SAWKILL ROAD.

ALREADY THERE'S TROUBLE.

BRIDGE CLOSED

IT'S A TINY WOODEN BRIDGE BEING REMADE IN STEEL AND IRON.

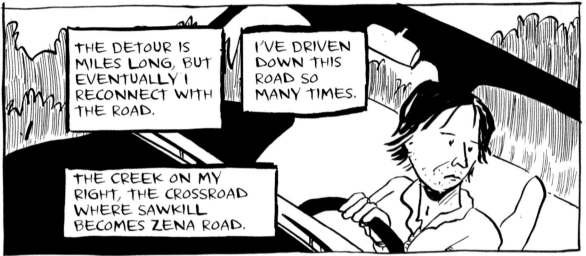

THE DETOUR IS MILES LONG, BUT EVENTUALLY I RECONNECT WITH THE ROAD.

I'VE DRIVEN DOWN THIS ROAD SO MANY TIMES.

THE CREEK ON MY RIGHT, THE CROSSROAD WHERE SAWKILL BECOMES ZENA ROAD.

A NEW HOUSE IS BEING BUILT ON THE ROAD.

THE INCLINE— WAS IT HERE?

HERE IT IS.

DEEP SET AMONGST THESE TOWERING PINES.

THEIR LAWN A MINI-FOREST.

I GOOGLE THE ADDRESS I'M STARING AT.

SOLD IN 2003. I CALL THE NUMBERS ON THE LISTING.

"DISCONNECTED." "NOT IN SERVICE."

THAT WENT NOWHERE.

BRIDGE CLOSED

I'M PRETTY DUMB IN A FOREST.

I KNOW A TREE FROM A BUSH, AND A PINE FROM A DECIDUOUS.

BUT I DON'T KNOW THIS LEAF.

I DON'T KNOW IF THIS TREE WAS SPLIT BY FIRE OR ROT.

I DON'T HAVE THE SLIGHTEST IDEA WHO MADE THIS TRAIL.

KATHRYN WAS ALWAYS MAYBE A LITTLE "TROUBLED."

THIS DISAPPEARANCE IS— WELL IT'S NOT TRAGIC I DON'T THINK.

BUT MAYBE IT'S THAT TROUBLE CATCHING UP?

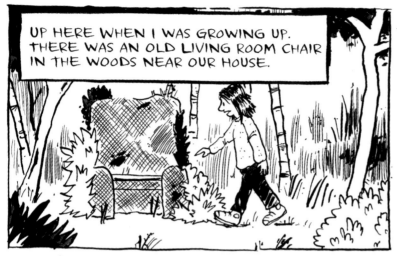

UP HERE WHEN I WAS GROWING UP. THERE WAS AN OLD LIVING ROOM CHAIR IN THE WOODS NEAR OUR HOUSE.

I WAS BAFFLED AND FASCINATED BY IT.

WHO PUT THIS HERE? WAS IT THRIVING? WAS IT IN USE? DISCARDED? WHO WAS WINNING THE BATTLE OF TIME? CHAIR, OR WOODS?

THE WOODS, NO DOUBT.

KATHRYN HAD ALWAYS BEEN HALF-DISAPPEARING.

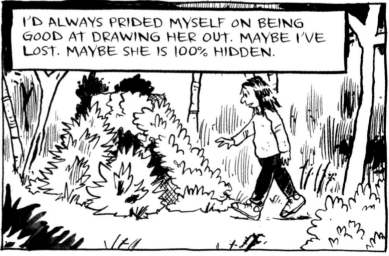

I'D ALWAYS PRIDED MYSELF ON BEING GOOD AT DRAWING HER OUT. MAYBE I'VE LOST. MAYBE SHE IS 100% HIDDEN.

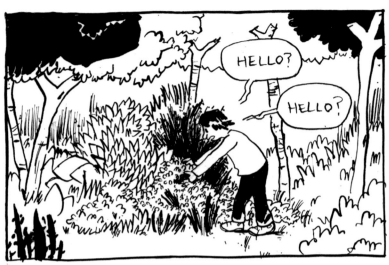

I DO MORE ONLINE SLEUTHING.

I HAVE A PAD OF PHONE NUMBERS.

I GET "NOT IN SERVICE."

"DISCONNECTED."

AND ONE "SORRY WRONG NUMBER" IN RESPONSE TO A TEXT.

THE WHOLE FAMILY IS MISSING OR AVOIDING ME.

I'M LOST ON MY COMPUTERS AND BOOKS. I'M READING AND WRITING.

I VISIT MY MADCAP FRIEND JUSTINE. SHE'S TRYING TO STILL HER MIND.

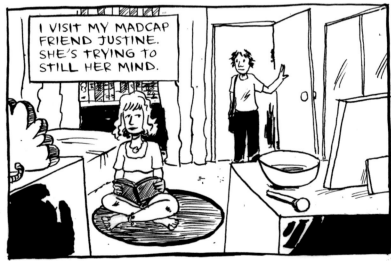

SHE FORCES ME ON A WALK THROUGH THE WOODS.

WHAT AM I DOING HERE? I HAVE TO WRITE MORE BOOKS, I HAVE TO MAKE MORE MONEY, I HAVE TO FIND MY FRIEND.

THIS TREE FELL DOWN YEARS AGO INTO THE CROOK OF THIS TREE AND NOW IT'S A <u>BRANCH</u>.

WHA?

SEE? IT'S GROWN INTO THE OTHER ...

AND THIS TREE FELL OVER, AND THE BRANCHES HAVE BECOME NEW TRUNKS.

AND THOSE TWO TREES ARE GROWING TOWARDS EACH OTHER...

WHY ARE THEY DOING THAT?

I DON'T KNOW...

The Art of the Graphic Memoir

166

I DIDN'T THINK I'D END THIS STORY EMPTY-HANDED.

I ENVISIONED REUNITING WITH MY FRIEND –

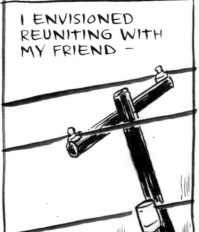

I'VE BEEN WONDERING WHERE YOU ARE!!

BUT MAYBE SHE'S UNREACHABLE. MAYBE SHE'S CHANGED...

PERHAPS NOW SHE'S A BIRD, A BEAR, A MAN, AND THAT'S WHY SHE'S HIDING...

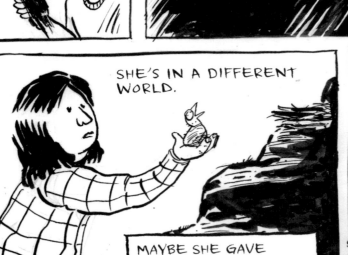

SHE'S IN A DIFFERENT WORLD.

MAYBE SHE GAVE HERSELF TO SOMETHING FOR SAFEKEEPING.

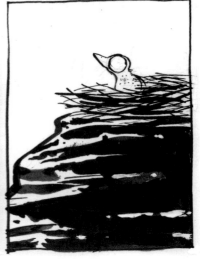

WE REACH A FIELD.

JUSTINE IS BAREFOOT AS ALWAYS. I AM COVERED IN BURRS.

ONE OF THE THINGS I COULD DO IN A FOREST WAS BE. WHAT CAN'T I DO THAT ANYMORE?

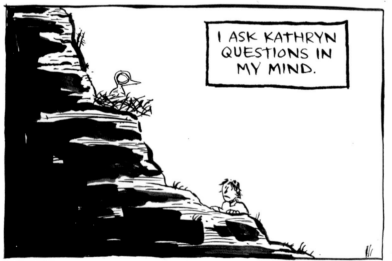

I ASK KATHRYN QUESTIONS IN MY MIND.

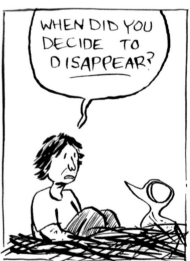

WHEN DID YOU DECIDE TO DISAPPEAR?

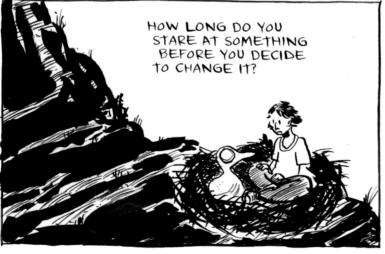

HOW LONG DO YOU STARE AT SOMETHING BEFORE YOU DECIDE TO CHANGE IT?

IF I DON'T WALK OUT HERE EVERY DAY, MY MIND GETS SO AGITATED AND FULL OF GARBAGE...

I TOUCH A SINGLE TREE. I'M WRITING THIS COMIC AS WE WALK. I'M THINKING ABOUT WHISKEY.

JUSTINE HELPS ME DRAW SOME OF THE SNARLS OF TRUNKS AND BRANCHES.

I USED TO BE WILD, BUT I'M A PIECE OF STUFFED FURNITURE...

YOU'VE GOT IT ALL WRONG.

SOMEONE SHOULD ABANDON ME IN THE FENS.

THE WORLD IS
HIDING FROM
ME.

I'M 17 AND
TRAVELING
THE FOREST
TO HER SMILE
AND HER
INTELLIGENCE.

I'M 48 AND
FRIENDS
ARE DYING
AROUND ME.

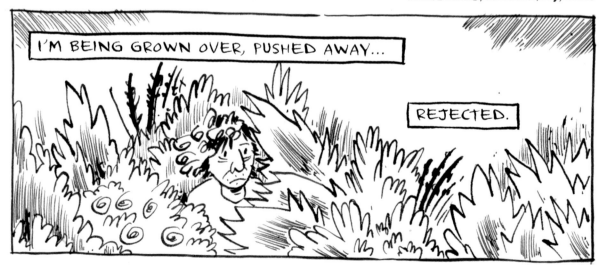

I'M BEING GROWN OVER, PUSHED AWAY...

REJECTED.

WHY ISN'T SHE HERE? WHERE THE TREES BEND TOWARDS EACH OTHER IN THE SKY?

IN THE FOREST, WHERE BRANCHES

AND TRUNKS—

MERGE TO FORM SINGLE TREES...

WHEN I WAS 17, MY CELLS AND PARTICLES AND WOULD HUM IN THIS FOREST...

NOW I'M STATIC, NOW THEY HIDE FROM ME TOO...

I TOUCH THIS TREE TO ASK—

THROUGH ITS PARTICLES AND POWER LINES—

CAN YOU TAKE ME?

CAN YOU SHOW ME?

ANYWHERE I CAN BE?

REFLECTION

For a lot of storytellers, the true drive to make the story is only understood after looking back and asking questions.

What was I trying to accomplish? What did I accomplish? What did I *experience* while telling this story?

For me, with Rosalie's book, I was just trying to merely get through it, but upon reflection, I realized I was trying to internalize thoughts that I had already had in the immediate aftermath of her loss. I also realized much later that I was trying to keep her vivacious spirit alive, but I never could have vocalized that then.

With this story, about the forest and my friend, I think I was trying to understand what it means to be growing old. I am trying to process loss, I think.

I have always been moved by drawings, and have always tried to improve my own drawings, and stay engaged with the process of drawing. And now I see that my old friend is gone, but I have a new friend who helps me in this quest to be engaged with lines and art. I learned as I worked on this story that this was one part that was trying to come out.

We often define ourselves by our young mind and ideals. Obsessed with youth and my younger, vibrant self, I think I was trying here to allow some space in my older self to be surprised and confused by things, in the way you are when you are younger.

DEBRIEFING

Looking back, I see that the gathering of material stirred up an interest in finding my old friend. It was the search for material that gave the story the key problem to solve: "Can I find my old friend?"

Inspired by *Why I Killed Peter,* I suspected I was writing a story that would culminate in a reunion scene, but it never emerged. I had to let the search for my connection to the forest and for Kathryn become a part of my everyday life. When it did, I opened up to new experiences that could be a part of the story.

I could ask again,

What story needed to be experienced?

Not fully aware of it, there were several.

First, I LOVED drawing all those trees.

And I loved abstracting them with ink line, lines I have used since I was a teenager.

Ultimately the story became an answer to the question I raised in the first chapter of this book, Why Comics? The answer came as I was working: that I love lines, and I feel like something is right when I am making them.

And finally, I have a friend under my nose now, who lives in the forest and with whom I can talk "books and life." She became a guide back, through art, line and drawing, to the forest.

OUTRO

This story was not an urgent story, not a story of trauma or joy, and so it had to find its motivation elsewhere. The gathering of material and some of the other exercises in this book were the engine that created the story.

Looking back, I see that the image of the chair arrived early, in chapter 1, but became a symbol only as I began to think about visual metaphor in chapter 7.

Further, many of the insights found in my live example in the Change Your Life chapter emerged as relevant themes in the new story. In fact many of them do, even if they aren't explicitly asked in the story. For instance:

- Have I become old and uncommunicative?
- Everything decays.
- We never really know each other.
- Who knows what trouble is underneath our behaviors?

What this shows me is that themes I am most interested in keep popping up again and again. This is probably true of you, too.

The goal of a memoir, I think, is continuity.

So much in this life and world seeks to fracture us, if not downright destroy us.

Through the telling of our own story, we find the signs in our life that say "I have existed, and I exist, and this is how and why." Through telling our story, we create our own meaning.

Through the process of writing and drawing our story, we can understand ourselves, communicate with parts of ourselves, and sometimes find ourselves face-to-face with our own complexity. With our own largeness.

Through sharing, we assert our indivuality, our expansiveness, and our humanity.

It's a gift others can share, but ultimately it's a gift to ourselves.

COPYRIGHT ACKNOWLEDGMENTS

My many thanks to the hundreds of people who have supported my work over the course of twenty-five years, too many to mention.

My many thanks to the artists and publishers in this book who have inspired me and allowed me to reprint their art.

Smile artwork © 2010 Raina Telgemeier, used with permission of Scholastic.
Barefoot Justine artwork © 2018 Justine Mara Andersen, provided courtesy the artist.
Theth artwork © 2014 Josh Bayer, provided courtesy the artist.
Perfect Example artwork © 2000 John Porcellino, provided courtesy Drawn & Quarterly.
Silly Daddy artwork © 2004 Joe Chiappetta, used with permission of the artist.
100 Demons artwork © 2017 Lynda Barry, provided courtesy Drawn & Quarterly.
Kampung Boy artwork © 2006 Lat, provided courtesy First Second.
NonNonBa artwork © 2012 Shigeru Mizuki, provided courtesy Drawn & Quarterly.
We Can Fix It! artwork © 2013 Jess Fink, provided courtesy the artist.
Graffiti Kitchen artwork © 1993 Eddie Campbell; used with permission of the artist.
David Chelsea in Love artwork © 1993 David Chelsea, used with permission of the artist.
Dance by the Light of the Moon artwork © 2010 Judith Vanistendael, used with permission of the artist.
How to Understand Israel in 60 Days or Less, artwork © 2011 Sarah Glidden, provided courtesy Drawn & Quarterly.
Make Me a Woman artwork © 2010 Vanessa Davis, provided courtesy Drawn & Quarterly.
July Diary and *Truth Is Fragmentary* artwork © 2012 and 2014 Gabrielle Bell, provided courtesy Uncivilized Books.
To the Heart of the Storm artwork copyright © 1991 by Will Eisner. Used by permission of W. W. Norton & Company, Inc.
Fun Home and *Are You My Mother?* artwork © 2007 and 2012 Alison Bechdel, provided courtesy the artist.
Can't We Talk About Something More Pleasant? artwork © 2014 Roz Chast, used with permission of the artist.
Soldier's Heart artwork © 2015 Carol Tyler, provided courtesy Fantagraphics Books.
Epileptic artwork © 2006 by David B. and L'Association.
Monsters artwork © 2009 Ken Dahl, provided courtesy the artist.
Why I Killed Peter artwork © 2008 Oliver Ka and Alfred, provided courtesy NBM Publishing.
Calling Dr. Laura artwork © 2013 Nicole J. Georges, used with permission of the artist.
The Photographer artwork © 2009 Emmanuel Guibert and Didier Lefèvre, provided courtesy First Second.
Maus and *MetaMaus* artwork © 1993 and 2011 Art Spiegelman, Pantheon Books.

Many thanks to Meg Thompson, Lauren Jablonski, Michael Homler, and Amelie Littell. Thanks to Jim Harrison for design assistance. Interior handwriting font by Jess Ruliffson. Cover art by Gabrielle Bell. Extra thanks to Carol Tyler, Gabrielle Bell, Josh Bayer, Justine Andersen and the students of SAW for wisdom, inspiration and guidance.

Tom Hart is the author/artist of *Rosalie Lightning* and the executive director of The Sequential Artists Workshop (SAW), a not-for-profit comics school and organization. sawcomics.org